ARIZONA'S
SCENIC SEASONS

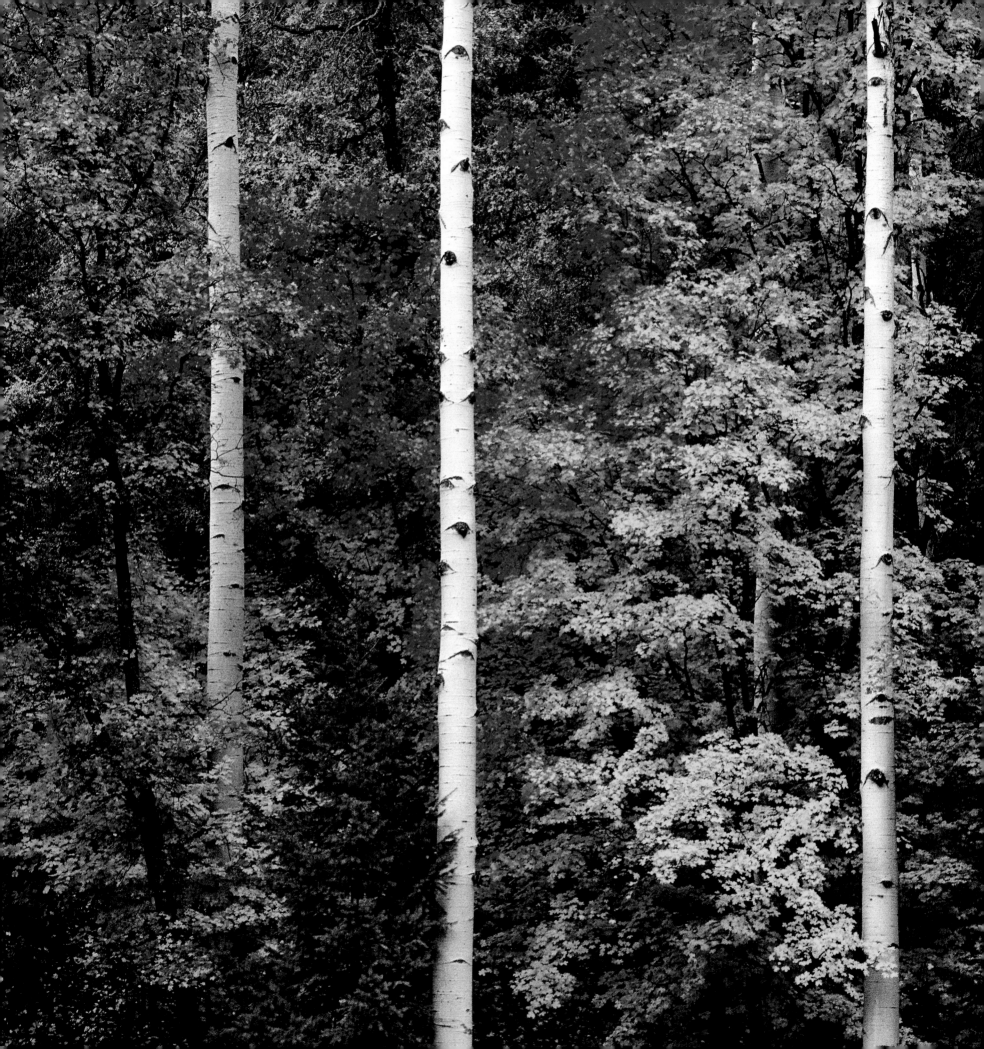

ARIZONA'S
SCENIC SEASONS

Text by Susan Lamb | Photographs by Arizona Highways contributors

The Unique Landscapes
of Spring, Summer, Autumn,
and Winter

Author: SUSAN LAMB

Photographs by *Arizona Highways* contributors

Photography Editor: PETER ENSENBERGER

Book Designer: MARY WINKELMAN VELGOS

Book Editor: RANDY SUMMERLIN

Copy Editor: BETH DEVENY

Map: KEVIN KIBSEY

Library of Congress Control Number: 2009921318
ISBN 978-0-9822788-0-2
First printing, 2009. Printed in China.

Published by *Arizona Highways* magazine, a monthly publication of the Arizona
Department of Transportation, 2039 West Lewis Avenue, Phoenix, Arizona 85009
Telephone: (602) 712-2200
Web site: www.arizonahighways.com

Publisher: WIN HOLDEN
Editor: ROBERT STIEVE
Senior Editor/Books: RANDY SUMMERLIN
Art Director: BARBARA DENNEY
Director of Photography: PETER ENSENBERGER
Production Director: MICHAEL BIANCHI
Production Coordinator: ANNETTE PHARES

FIRE ON THE RIM
[frontispiece] The pale trunks of aspen
trees frame brilliant fall foliage in Gem
Draw on the Mogollon Rim.
| *Nick Berezenko*

[right] Biologists divide Arizona into
three main regions: the Plateau, the
Central Highlands, and the Low
Deserts, which are further divided
into the Sonoran, Mohave, and
Chihuahuan deserts. Each of these
regions has its own distinctive climate
that determines its plants and many of
its animals, giving each region a unique
character from season to season. The
boundaries of these regions overlap and
mingle, as is so often the case in nature.

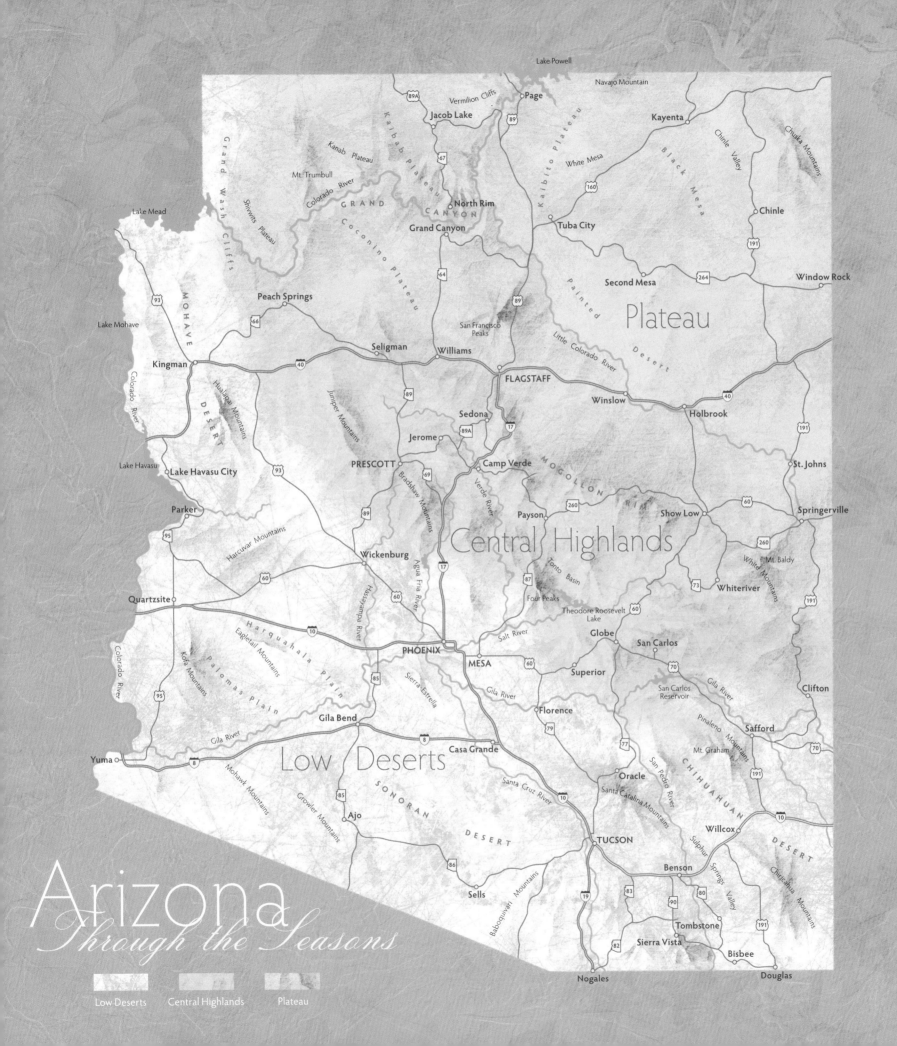

Lake Powell

89A
Vermilion Cliffs
Jacob Lake
Page
Navajo Mountain
Kayenta
Chuska Mountains

Kanab Plateau
89
White Mesa
Chinle Valley
Chinle

Kaibab Plateau
67
160

Grand Wash Cliffs
Mt. Trumbull
Colorado River
GRAND
CANYON
North Rim
Black Mesa

Shivwits Plateau
Coconino Plateau
Grand Canyon
Tuba City
191

Lake Mead

64
Second Mesa
264
Window Rock

89
Painted Desert

Peach Springs
93
San Francisco Peaks
Plateau

66
Little Colorado River

Lake Mohave
MOHAVE
Kingman
40
Seligman
Williams
FLAGSTAFF
Winslow
Holbrook
40
191

DESERT
Hualapai Mountains
Juniper Mountains
89
Sedona
17
89A
Jerome
MOGOLLON

Lake Havasu
Lake Havasu City
93
PRESCOTT
Camp Verde
St. Johns

Harcuvar Mountains
Bradshaw Mountains
69
260
191

Parker
95
89
Wickenburg
Verde River
Payson
Show Low
60
Springerville

Colorado River
Harquahala Mountains
Agua Fria River
Central Highlands
Tonto Basin
73
260
Mt. Baldy
White Mountains

Quartzsite
60
17
Four Peaks
87
Whiteriver
191

Eagletail Mountains
10
Hassayampa River
Theodore Roosevelt Lake
60

Kofa Mountains
Palomas Plain
60
Salt River
Globe
San Carlos
70
Gila River
Clifton

95
85
PHOENIX
MESA
60
Superior
San Carlos Reservoir
Pinaleno Mountains
Safford

Yuma
8
Gila River
Gila Bend
Sierra Estrella
Gila River
Florence
79
Mt. Graham
77
70
191

8
Casa Grande
Santa Cruz River
Oracle
Santa Catalina Mountains
San Pedro River
CHIHUAHUAN

Mohawk Mountains
85
Low Deserts
SONORAN
Willcox
10

Growler Mountains
Ajo
DESERT
TUCSON
Benson
Sulphur Springs Valley
DESERT

86
Sells
19
Santa Catalina Mountains
83
90
80
Tombstone
Chiricahua Mountains
191

Baboquivari Mountains
82
Sierra Vista
Bisbee

Nogales
Douglas

Arizona
Through the Seasons

Low Deserts Central Highlands Plateau

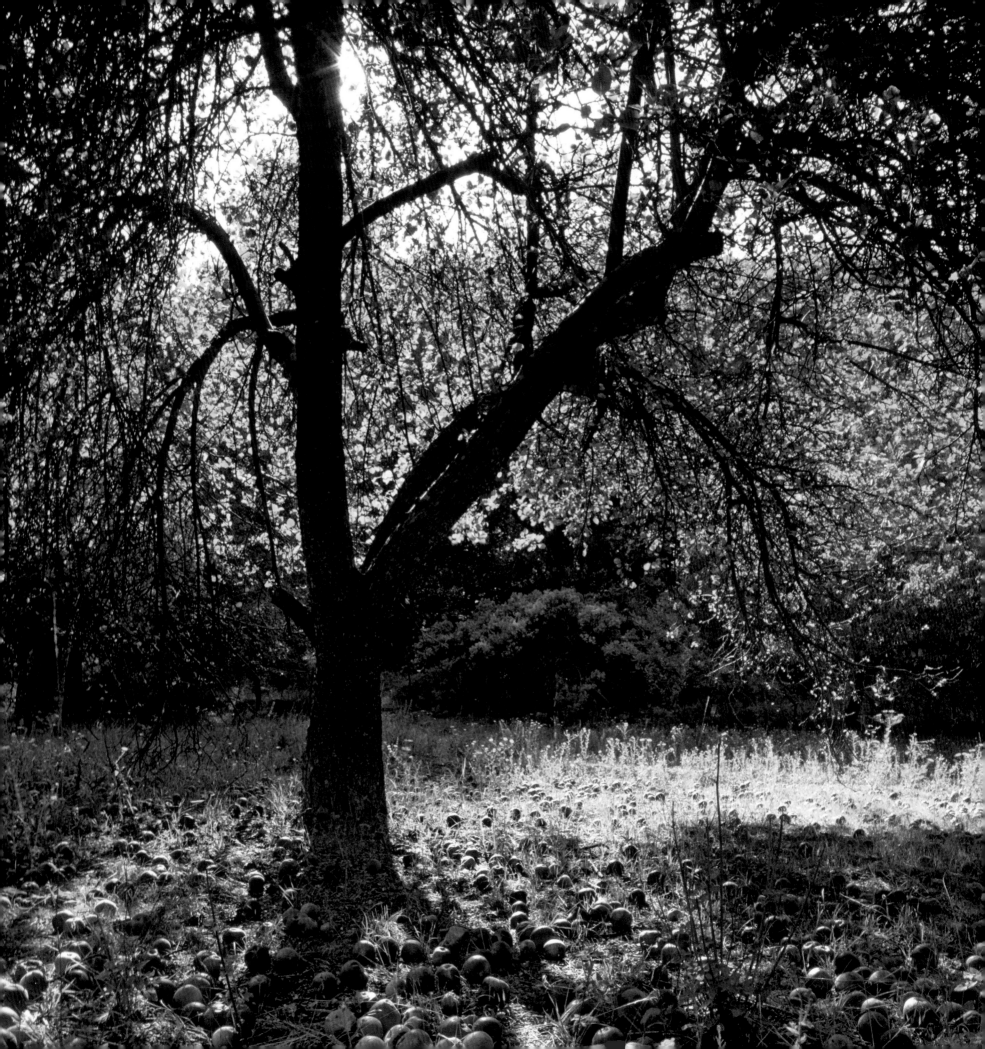

FORGOTTEN HARVEST
In autumn, fallen apples litter the old orchard at the abandoned
Reavis Ranch in the Superstition Wilderness. | *Frank Zullo*

Arizona *Through the Seasons*

The wild and primitive region which constitutes the Territory of Arizona

exhibits a remarkable diversity of surface in its mountain

ranges, grassy plains, and desert wastes; and its Fauna and

Flora are varied in a corresponding degree. The traveller

meets, at each successive day's journey, new and strange

objects, which must interest him, if only through the wonder

and astonishment they excite.

— *Elliott Coues,* Army surgeon
Fort Whipple, Arizona Territory, 1864–6

| Tom Bean

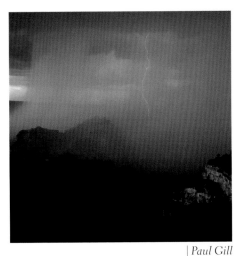
| Paul Gill

| Randy Prentice

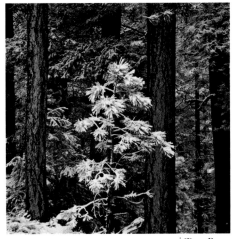
| Tom Bean

The seasons of Arizona make cheerful pilgrims of us all, calling us on quests of "wonder and astonishment." We descend on the deserts in spring, beckoned by acres of Mexican goldpoppies and purple scorpion-weeds. Summer finds us confronted by topography as we trek or climb or drive among Arizona's remarkable landscapes. In autumn we seek out radiant golden cottonwoods along a stream or make bittersweet journeys to upland forests of fluttering yellow aspen leaves and rust-red oaks. Winter's devotees head for high country snow or the southern haunts of migratory birds.

Some think of Arizona as the land of eternal summer and, in a way, it is. Most Arizonans live in the Sonoran Desert, where clear blue skies prevail and the average annual temperature is around seventy degrees. But we find all the seasons in Arizona. Summers are longer at low elevations; winters persist up high. Wildflowers bloom near Yuma while snow falls on Flagstaff. Whether in desert or chaparral, grassland or forest, each season awakens us to Arizona's extraordinary scenery.

Seen from space, Arizona is as corrugated as corduroy. From the wide parallel basins and worn-looking mountain ranges of the southern deserts to the long valleys and rugged mountains of the Central Arizona Highlands across the middle to the concentric arcs of bluffs and escarpments of the plateau country in the north, the landscape is ridged like waves lapping on sand. Each region provides a dramatic setting for the breathtaking sunrises and sunsets — and sensational summer thunderstorms — for which Arizona is justly famous.

Spectacular landforms, distinctive communities of plants and animals, and glorious skies combine to create the incomparable scenery of Arizona. Together they offer the pilgrims among us countless unforgettable journeys in every season of the year.

Arizona's First Resident Scientist

Elliott Coues was only twenty-one years old when he reported for duty to the rough log palisade of Fort Whipple. As Arizona's first resident scientist, he saw his duty as "to shoot up the country between the Rio Grande and the Rio Colorado." His solitary rides into unknown and frequently hostile country drove his fellow soldiers frantic with worry, which on one occasion they eased by drinking Coues' cask of preserving alcohol. Only after they had drunk their fill and smashed the barrel did they discover that it already held quite a few lizards and snakes.

Spring *Flower Quests*

Our lives attain a new level of enrichment when we gain the ability to recognize as friends the plants and animals of our own environment. We can go through the seasons expecting encounters with them at times and places magically predetermined. They greet us on every hand, and add dimensions of meaning and belonging to every outdoor experience.

— *Robert De Witt Ivey*, nature author

DAZZLING DISPLAY
Mexican goldpoppies announce spring from a Sonoran Desert slope above Bartlett Reservoir in the Tonto National Forest. | *Tom Bean*

Bruce D. Taubert

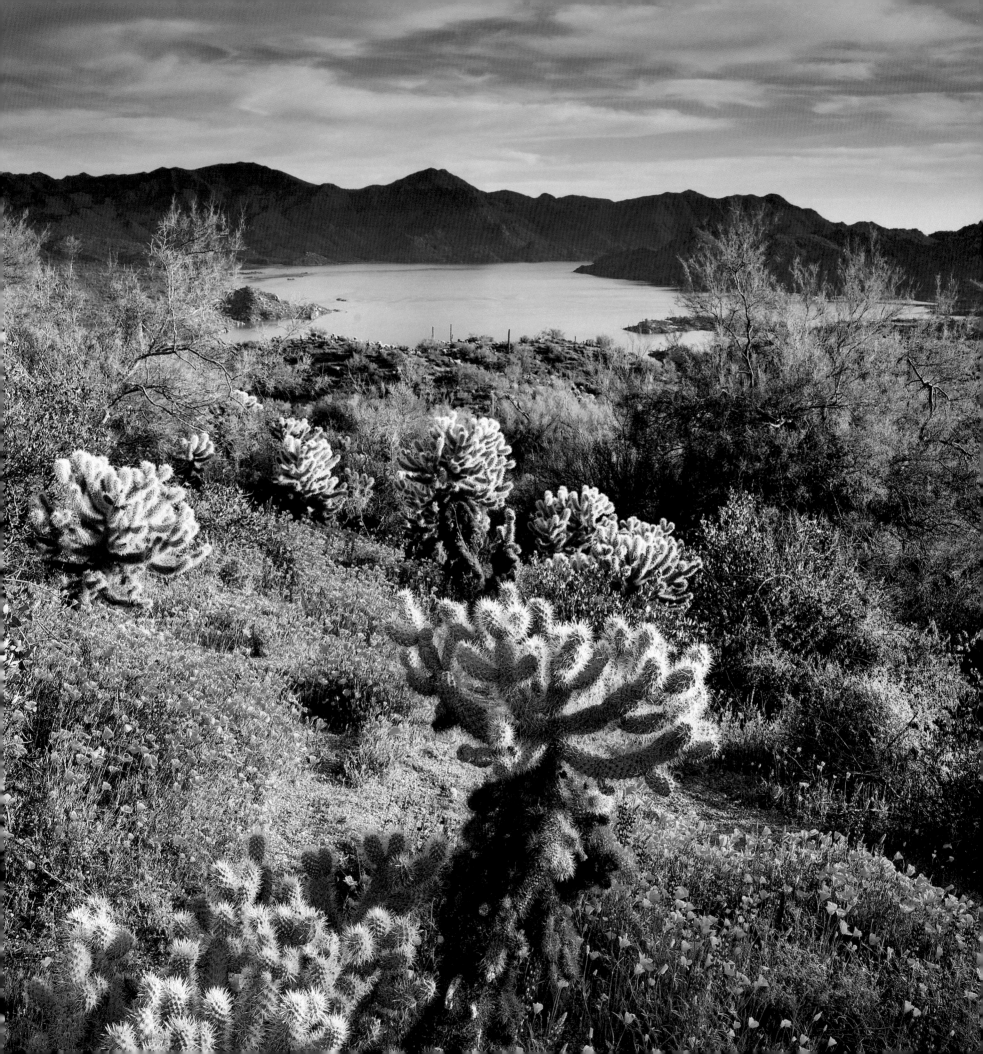

The seasons wander through Arizona at their own speed, ignoring the usual dates to start and finish. Generally, they are more in line with how seasons have been reckoned by traditional people, including some of the ancient people of the American Southwest as well as medieval Europeans. Preindustrial people considered the dates midway between the solstices and equinoxes to be the beginnings and ends of the seasons. They looked for signs of spring around February 2, summer as early as May 1, autumn about August 5, and winter around November 1. In Arizona, expecting seasonal changes near these traditional dates turns out to be much more practical than waiting for the official start of summer on June 21, for example, to shed our sweaters.

Spring arrives in Arizona from the south, along the desert rivers. As the days grow longer and sunlight warms the earth, migrating birds and butterflies flutter up the rivers — the Colorado and the Gila, the San Pedro and the Santa Cruz. Light-green leaves decorate the pale branches of sycamores, catkins dangle from willows, and cottonwoods launch bits of fluff that float on the air like snowflakes. Soon, courting songbirds whistle and trill. Spring peepers call from streams and ponds renewed with trickling meltwater. As the weeks go by, signs of spring occur farther and farther north and higher and higher in elevation, extending the season from late January into May.

The surest sign of spring is the blossoming of wildflowers. What has been most noticeable about the winter landscape — its architecture of mountains, canyons, and wide-open plains — becomes a mere backdrop for the exuberant re-emergence of life. Spring can be astonishing after winters of good rain, when waves of wildflowers suddenly flood the warm deserts.

For most of the twentieth century, it was verboten for a scientist to say "the flower beckoned the butterfly." To imply such a thing was considered poetic license by some and dismissed as foolishness by most. Now we know better. Science today rivals poetry at times, and we've learned enough to realize the plants themselves are the poets. Research has shown how fluently plants communicate,

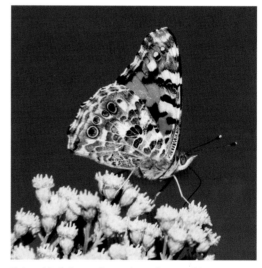

Painted lady butterfly on desert broom. | *Bruce D. Taubert*

not only with insects but with other plants and also with animals, including us. Their color, shape, fragrance, and other subtle chemistries are eloquent and specific: chuparosas catch the attention of hummingbirds, evening primroses lure moths, and milkweed summons butterflies. We respond to the beckoning of flowers just as these pollinators do: We go to where the flowers are. Butterflies seek nectar; we seek delight.

Sonoran: Waves of Color and Scent

Plants are the most considerate of our pilgrim companions, waiting quietly in the background until they burst into bloom. Well, perhaps that isn't always true; saguaro cactuses always seem to be shouting "Hey! You're in the Sonoran Desert!" Saguaros are the unmistakable indicators of the Sonoran, as their great size is possible only because their desert has two rainy seasons: winter and summer.

Spring comes first to the lowest and driest part of the Sonoran Desert along the lower Colorado River. In years of good winter rains, scarlet flowers flare on the branch tips of ocotillos and chuparosas even before the days begin to lengthen. By February, dunes erupt tufts of ajo lilies and hot-pink sand verbena; sandy places come alive in the cool hours of dusk with white and yellow evening primroses

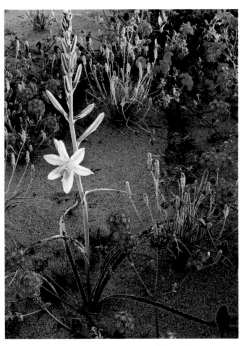

Ajo lily in patch of sand verbena. | *Randy Prentice*

and their visiting hawk moths. In washes and ravines, beavertail cactuses close their gorgeous magenta blossoms in late afternoon and are slow to open again the next day. Creosote bushes, evenly spaced across the flats, shine with sticky leaves and little yellow flowers. Scatterings of other wildflowers — yellow bladderpod mustard, purple mat, and salmon-colored desert globemallow—brighten windswept desert pavement. Filaree, a tiny purple geranium introduced early in Spanish missionary days, blooms here too.

The desert around Yuma is close to sea level, but traveling from there toward the center of the state brings us ever higher into conditions that are cooler and more moist. Flowering happens a little later. As the weeks go by, ephemeral wildflowers, as well as perennial desert marigolds and brittlebush, take turns reaching their peak colors.

Indicator Species

There are three "warm" deserts in Arizona: the Sonoran in the southwest, Mohave to the northwest, and Chihuahuan in the southeast. All three are landlocked oceans of creosote, mesquite, and ocotillo. How can we tell them apart? The *indicator* plants will let us know. These are the plants uniquely adapted to the specific climates of each desert — saguaros to Sonoran, Joshua trees to Mohave, and American tarwort to Chihuahuan.

13

Spring

Wonderful Whoppers

Let us enjoy the sweet songs and behold the harmonious varieties of the colorful plumage of the countless birds that fly through this air.
— Juan Nentvig, S.J. 1764

Juan Bautista Nentvig was a Jesuit missionary in the 1750s, when the Spanish province of Sonora included what is now Southern Arizona. His Rudo Ensayo ("Rough Essay") is full of wonderful whoppers about the region, such as his description of a tarantula biting off the hoof of a galloping horse. One has to wonder why he made things up. The truth about Arizona is astonishing enough.

Craggy, much-eroded mountain ranges encircle the Sonoran Desert and crinkle the flatlands of its interior. The richest of Arizona's desert flora inhabit the gravelly slopes at their feet. Saguaro cactuses tower thirty feet or more above paloverde trees and waist-high forests of teddybear cholla, shrubs, agaves, yuccas, and scores of smaller flowering plants. After rainy winters, masses of wildflowers suddenly explode into riotous bloom on the sloping uplands. For a few short weeks, midmorning finds millions of Mexican goldpoppies flaring on south-facing hillsides, their deep-orange glow visible from miles away. A closer look finds blue and purple flowers — wool stars, phacelia, lupines — and deep pink owl's clover mixed with them. Yellow fiddleneck, pink fairyduster, creamcups are each exquisite in color and shape.

Trees eventually get their turn to brighten the Sonoran spring. Halos of yellow blossoms light up mesquites and acacias and saturate the lime-green branches of blue and littleleaf paloverdes. Clouds of violet flowers surround the ironwoods and the desert willows along the draws. The saguaros' crowns of white flowers attract longnosed bats, doves, and bees.

Mohave: Flurries of Flowers

North of Lake Havasu, the desert is a lonesome sea of creosote minus saguaros. But on the fringes of the Mohave Desert, creosote suddenly has company. An army of Joshua trees trumpets spring with dense clusters of greenish-white flowers on shaggy, uplifted branches. The Joshua tree is the undisputed symbol of the Mohave Desert, even though its smaller cousin, Mohave yucca, takes its place in most parts of the region.

The Mohave has a lot in common with the Sonoran Desert, at least in springtime. Winter rains that move in off the Pacific Ocean prompt many of the same wildflowers to bloom in both deserts: lupines, goldpoppies, owl's clover. Brittlebush, prickly poppies, and beavertails also flower here.

But in spite of their similarities, the Mohave and Sonoran deserts just don't look that much alike. Unlike the Sonoran, the Mohave Desert undergoes prolonged freezes in winter that delay the bloom of spring flowers and prevent saguaros from becoming established. Summer rains seldom reach this far, and fewer plants can survive the Mohave's extreme heat at that time of year. Although some of them are shared with the Sonoran, several wildflowers

are so associated with the Mohave that it is part of their names: *Mohavea confertiflora* (ghostflower), *Mohavea breviflora* (golden desert-snapdragon), Mohave aster, Mohave brickellbush, Mohave desertrue.

The Mohave Desert can seem a spartan domain of arid soil dotted with dark bursage and greasewood, blackbrush and saltbush, creosote and cholla. Yet it also presents a graceful immensity against its backdrop of low mountains and the distant Grand Wash Cliffs. Such wide-open vistas entice people who like their own space, as evidenced by the many simple homesteads in the Mohave Valley.

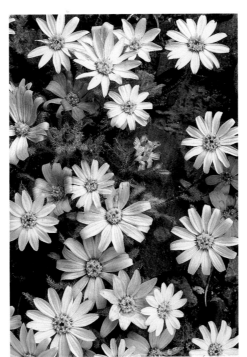

Mohave desertstar. | *Bruce Griffin*

Chihuahuan: Scattered Blossoms, Lingering Snows

In Arizona's southeast corner, American tarwort could tell an especially observant person that he had reached the Chihuahuan Desert. But unlike Joshua trees or magnificent saguaros, American tarwort is a modest little shrub among many others. Creosote, saltbush, mesquite, mariola, ocotillos, agave, and yucca make the Chihuahuan a brushy, spiky place. The gray-green leaves of American tarwort and the small yellow flowers along its stems are not especially conspicuous. American tarwort asserts its presence another way; it reeks of varnish.

Although winter rains are meager in Chihuahuan valleys, pink-flowering brownfoots and desert evening primroses blossom in spring along dry washes where desert willows bear fragrant flowers buzzing with bees. Mule deer drift through tawny tobosagrass dotted with Chihuahuan vervain and scores of ephemeral wildflowers in the San Simon and San Pedro valleys. Desert box turtles with yellow starburst patterns on their shells wander the grasslands eating beetles and leaves. With the right combination of warmth and moisture, grama and

The First Europeans in Arizona

From here we traveled over a hundred leagues, always finding permanent settlements and much corn and beans to eat. The people gave us many deer and cotton blankets better than the ones from New Spain. They also gave us many beads and a kind of coral from the South Sea, along with many very fine turquoises from the North. In sum, they gave us everything they had.
— Alvar Nuñez Cabeza de Vaca,
La Relación 1542

Europeans first entered Arizona in the Chihuahuan region. Cabeza de Vaca and three companions probably crossed it in 1536 during their eight-year journey to Mexico from the Texas coast, where their fleet had foundered. Fray Marcos de Niza went through in 1539, seeking treasure in New Mexico. In 1540, Coronado's expedition found water and game along the San Pedro River for 358 men-at-arms, their slaves, servants, quite a few of their wives, and 1,300 natives from Mexico. There was forage enough for their cattle, sheep, and 500 horses. Despite this natural abundance, Captain Juan Jaramillo called the area *despoblado* (unpopulated). It is still only lightly settled today.

lovegrass tinge the foothills green, a pleasing background to Mexican goldpoppies. Orangetip butterflies flicker to fleabanes, pepperweeds, and blanketflower.

Ranges of high mountains, called "sky islands" because of their isolated and diverse habitats and wildlife, extend from the Chihuahuan Desert into the southeastern edge of the Sonoran Desert. They intercept much of the winter rain that might otherwise reach the Chihuahuan lowlands. Rocky Mountain plants and animals mingle on these mountains with those of Mexico's Sierra Madre. In spring, painted redstarts arrive from the south to breed and summer here. Bands of coatis rummage for insects and seeds in woodlands of Emory, Mexican blue, and silverleaf oaks, alligator junipers, and Mexican piñon pines. Ponderosa, Apache, and Chihuahua pines appear still higher and, in turn, merge with mixed conifers and aspens at the upper elevations. Creeks flow down through all of these woodlands in sycamore-shaded canyons, creating oases for wildlife from hummingbirds to javelinas.

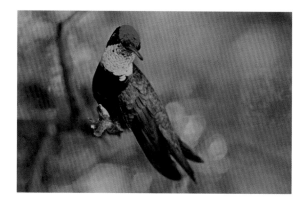

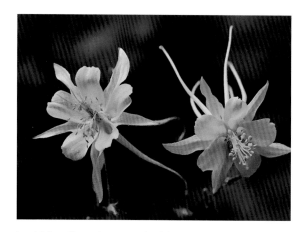

[top] Magnificent hummingbird. | *C. Allan Morgan*
[above] Golden columbine. | *Neil Weidner*

Warm weather comes late to the Sky Islands, and the plants have adapted. Manzanita puts forth small, barely open pink flowers in defiance of lingering snows. Soon, golden columbine and scarlet monkeyflowers gleam in the cool shadows along the streams; delphiniums emerge in sheltered forest glens. Great purple hairstreak butterflies flit in the shadows of oak woodlands searching for nectar, while satyr comma butterflies perch on trees and watch for females in late afternoon.

Central Highlands
Patchwork of Plant Communities

Across the middle of Arizona, mountain ranges and narrow plateaus alternate with long, high valleys. These are the Central Arizona Highlands, a biological and geological jumble where plant communities from north and south, east and west, high and low intermingle.

No plant could possibly do all the talking for the Central Arizona Highlands. The region has such scrambled topography that a dozen or so different plant communities are found here — desert scrub, two types of grassland, chaparral, two dry woodlands, two moist woodlands, and three coniferous forests. Of these, chaparral probably has the most to say about this part of Arizona.

There is more chaparral in the Central Arizona Highlands than in any other region of the state. It covers between two and three million acres of rough country from Seligman to Safford. Chaparral, generally gray-green, is named for *Quercus turbinella*, the fierce little scrub oak called *chaparro* in Spanish. Scrub oak dominates its scratchy community of about fifty different shrubs — manzanitas, mountain mahoganies, sumacs, silk tassels, ceanothus, and more. Chaparral is so in league with fire that seeds of many of its members sprout only in response to flame or smoke.

Javelinas and mule deer range through the chaparral's snagging, twiggy brush and bunchgrasses and beargrass, prickly pears, agaves, and yuccas. Spring comes later than in the deserts below but, when it finally arrives, little pink and blue flowers form pastel clouds around many of the shrubs. The strange, sweet scent of ceanothus fills the air. Paintbrush makes crimson splotches and Palmer's penstemons bear pale-pink blooms on stalks up to five feet tall. Many different penstemons flourish here, flowering in a range of colors from violet to blue to red as spring shifts into summer.

Indian paintbrush. | *Tom Bean*

Semidesert grassland sprawls across Agua Fria National Monument, just over the rim from the Sonoran saguaros of Black Canyon. People moved there from the valleys below during a catastrophic drought in the thirteenth century and built countless little checkdams to confine the skimpy soil and capture the rain. They lived in large pueblos with dozens of rooms and tapped petroglyphs into the cliffs below the mesas. In spring, the scene of their remarkable survival comes alive as deep orange mariposa lilies, magenta Engelmann's hedgehogs, bluedicks, fairydusters, and desert globemallows speckle the winter-bleached grasslands with color.

On February 2, the sun rises in alignment with an opening in a "calendar wall" at an 800-year-old sandstone pueblo in the Painted Desert. This alignment may have long been a cue to commemorate and encourage the renewal of life that occurs in spring. The Hopi ceremony of Powamu is associated with this date together with the first phase of the moon. Participants offer bean plants that have been sprouted indoors with great devotion, and invoke the rain needed during the growing season. However, they usually wait to plant beans in the ground until wild *duduna* (spring parsley) is in bloom, an assurance that hard frosts are over.

Plateau Country
Late but Lasting

Spring comes to the plateau country in fits and starts. As the jet stream begins its retreat to the north, warm afternoons alternate with brisk, windy weather or sometimes, even snow. This pattern can repeat itself for weeks.

Northern Arizona is associated with the Great Basin, a cold sagebrush desert centered on Nevada to the northwest. The area conveys that wide-open, empty, windswept feel, especially in the blustery spring. But familiarity reveals a different character, a place well loved and well lived-in for thousands of years. The

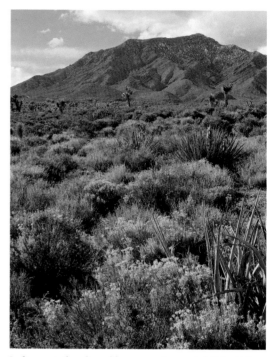

Indian paintbrush and broom snakeweed. | *Robert G. McDonald*

indigenous people of this region — Hualapai, Havasupai, Hopi, Navajo, and Paiute people — consider it the center of the universe, and a place where they have everything they need.

The average elevation of the plateau country is about a mile above sea level so winters here are relatively cold. Even when we observe other signs of spring — days lengthening, birds calling — the wildflowers here can be timid. Plants are conditioned not to risk flowering in the midst of uncertainty. Wildflowers bloom to be pollinated, and their companion insects aren't likely to emerge under wintry conditions. The first spring bloomers are few. Most plants take a while to wake up and lots of them snooze until summer.

At some vague point it happens: Spring arrives in the plateau and canyon country. Western meadowlarks sing on grasslands, where fresh new green shows under straw-colored plumes from the previous year. Fleabanes open each morning; pink windmills shyly unfurl. The canyon wren's sweet decrescendo echoes from canyons where desert blazing star and claretcup cactuses bloom.

This flat-looking landscape is split by canyons, uplifted into plateaus, eroded into cliffs and mesas, and punctuated here and there by volcanic features. Much of it is scrubby sagebrush desert and grasslands. There are also piñon and juniper-clad hills where prince's plumes and spreading phloxes flower in late April and pinyon jays form pairs out of their noisy flocks.

The largest continuous stand of ponderosa pines in the world engulfs the high plateau country between about 6,000 and 8,000 feet. It is a bird-friendly forest, musical in spring with the drumming of flickers, the cheeps and callings of chickadees, juncos, and nuthatches. Just a few small flowers welcome spring from the semi-shade of the tall trees — among them pennycress, wood betony, valerian, draba, paintbrush, and gromwell.

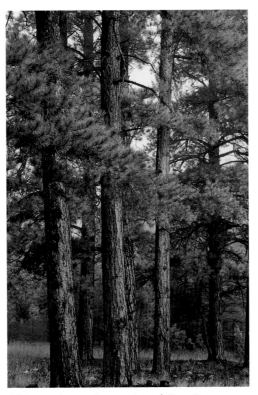

Old-growth ponderosa pines. | *Tom Bean*

Above the ponderosas, Townsend's solitaires sing their haunting notes in a dense spruce-fir forest too cold and dark for spring flowers. Snow still buries the alpine meadows on the San Francisco Peaks and White Mountains. In places so high as these, the bloom is delayed until June.

Plant Companions

A bright spot in the often-tragic encounters between native people of the Southwest and European missionaries was their sharing of plants. Both cultures relied upon botany for healing, decoration, ceremonies, and foods. Plants were used not only as cures for the body but also for the soul in rituals and celebrations. Somehow, this fell out of favor for a century or so, but many Southwestern people never lost faith in their herbal companions. Recent studies have verified the healing properties of many plants, and neurologists confirm that the mere presence of plants soothes and uplifts us.

JUST THE SPOT
[right] Granite boulders trap moisture and store warmth, creating niches for purple nightshade in the Mazatzal Mountains. | *Nick Berezenko*

PRETTY IN PINK
[opposite page] A redbud tree blooms from a crack in the wall of shady Hualapai Canyon on the Havasupai Indian Reservation. | *Robert G. McDonald*

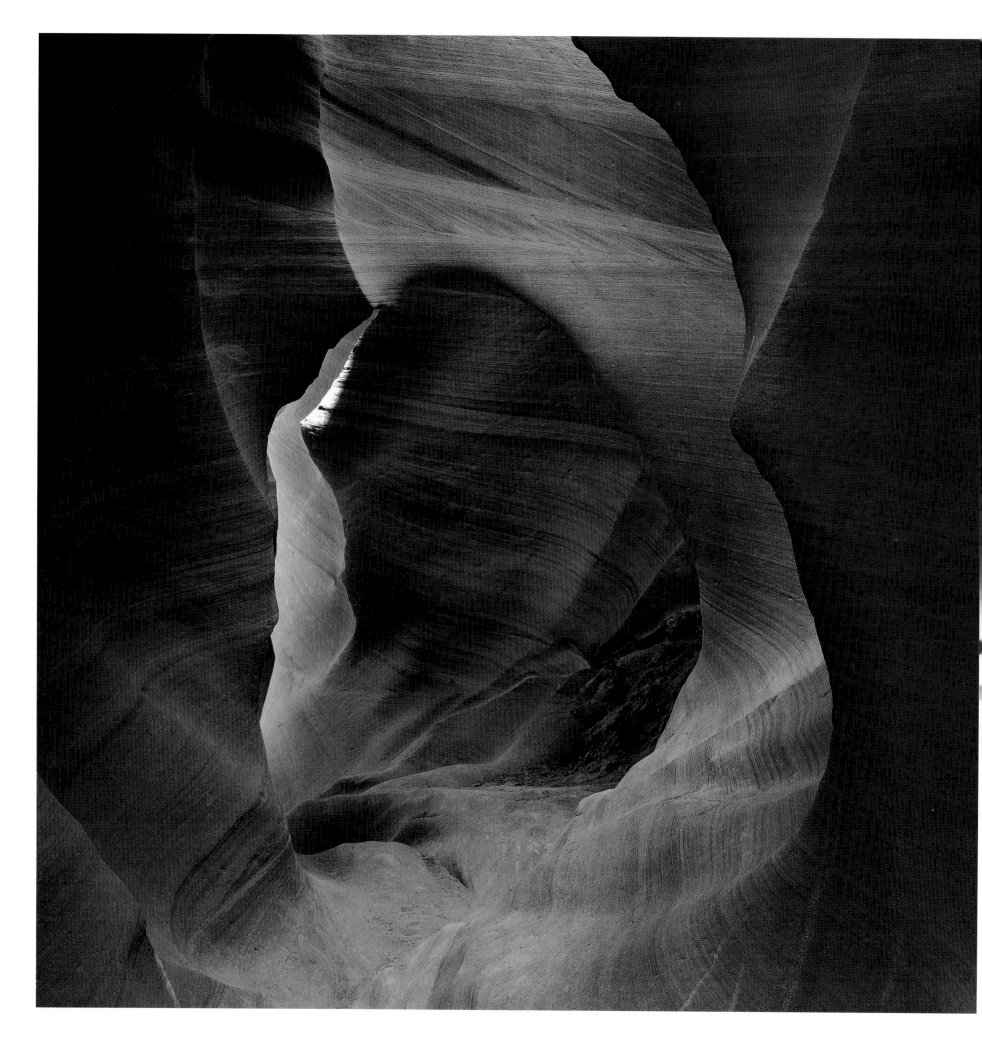

STONE
ILLUMINATIONS
[opposite page] In
springtime, gentle
light filters into Lower
Antelope Canyon near
Page on the Navajo
Nation. | *Jerry Sieve*

MAGENTA MAGIC
[above] Engelmann
hedgehog and beavertail
prickly pear cactus
flowers capture the
evening light northeast
of Kingman. | *Robert G.
McDonald*

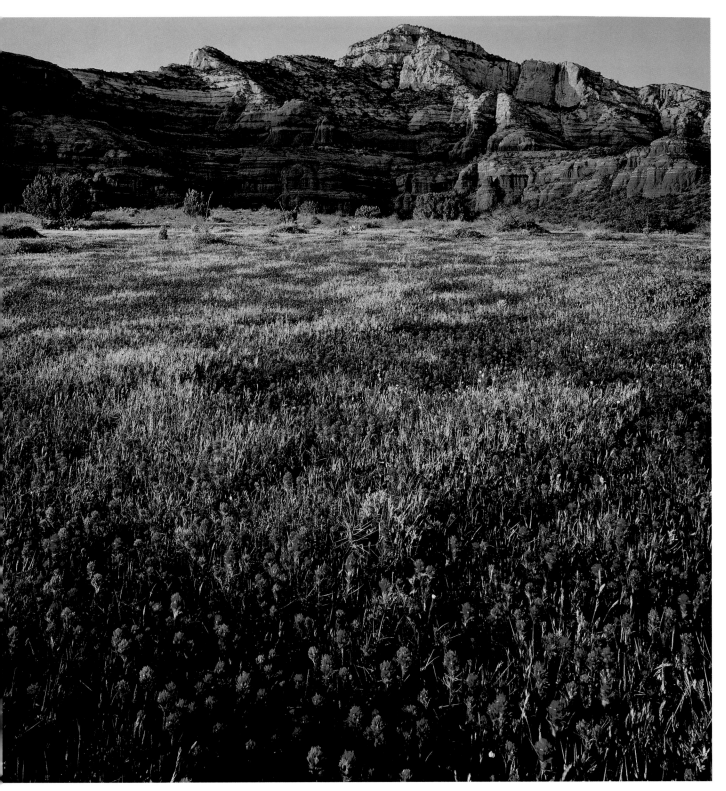

SUNSET SENTINEL
[opposite page] Framed
by twin ocotillos, the
isolated Kofa Mountains
glow in the last rays of
the setting sun. | *Paul
Gill*

A BEE'S DELIGHT
[left] Masses of owl's
clover spill over the
ground near Red
Canyon west of Sedona,
Coconino National
Forest. | *Robert G.
McDonald*

STARRY SPINES
[above] Pale spines accentuate the symmetry of a senita cactus branch at Bates Well, Organ Pipe Cactus National Monument. | *Nick Berezenko*

BLOSSOMS AND BRISTLES
[opposite page] Brittlebush and lupine steal the show from teddybear cholla and a barrel cactus, Kofa National Wildlife Refuge. | *Jack Dykinga*

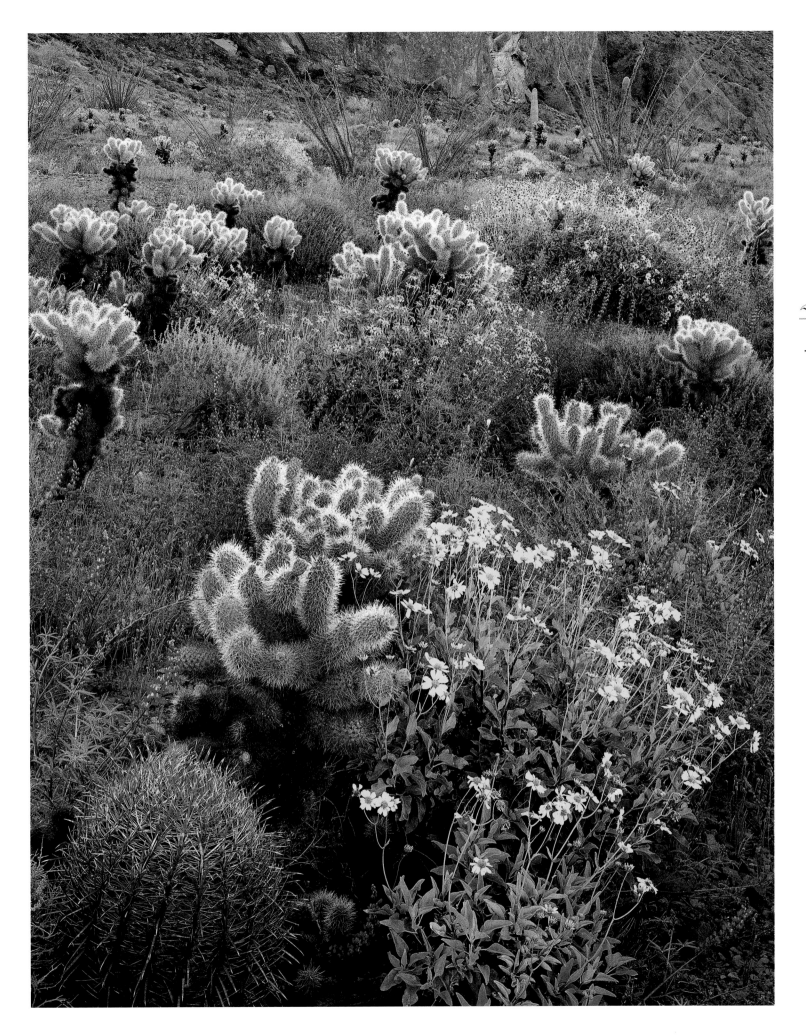

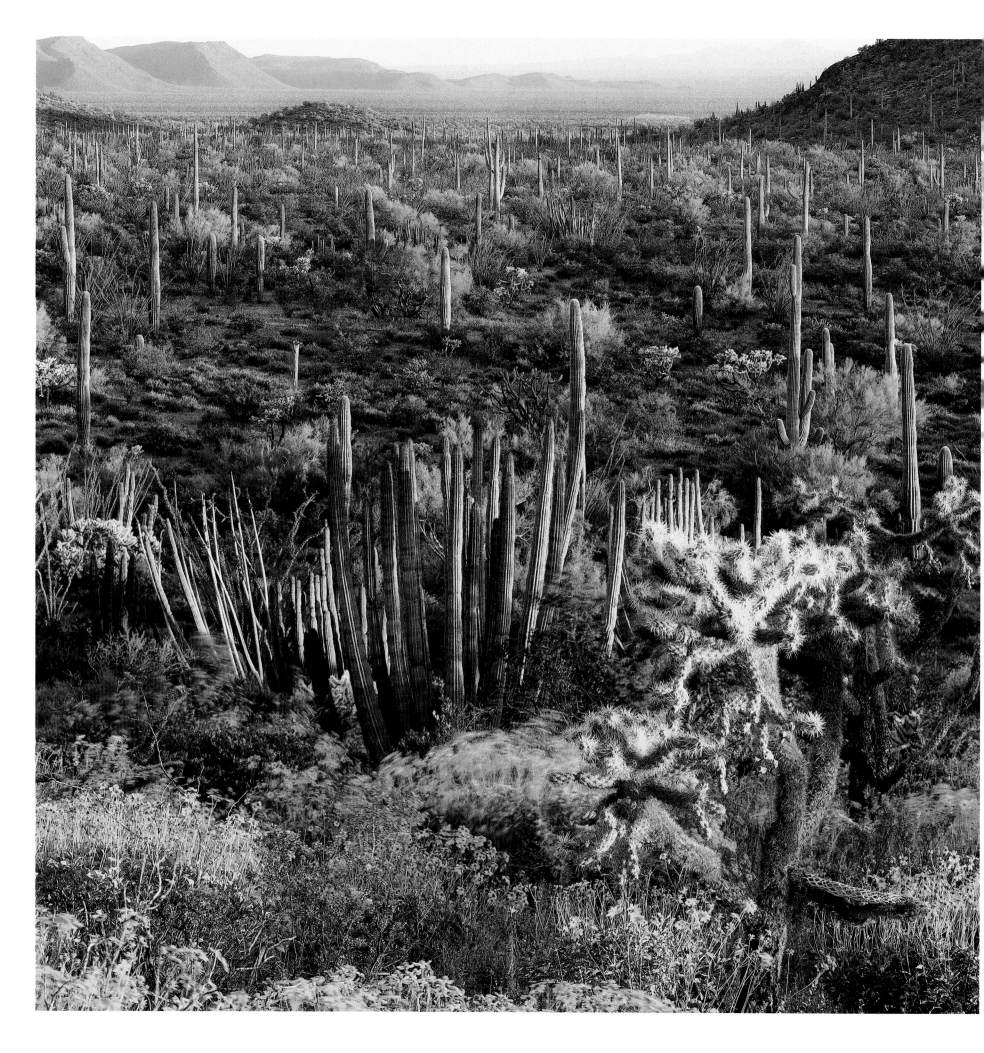

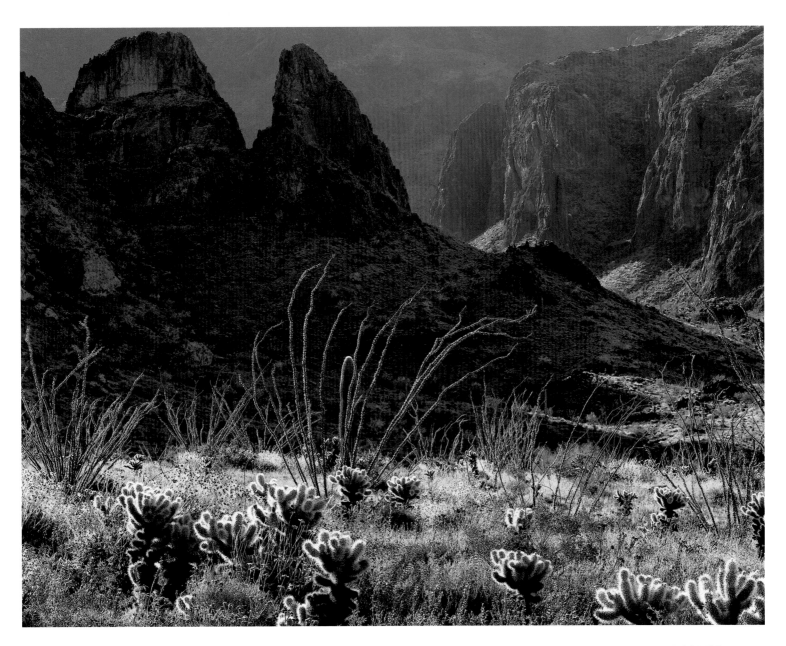

ORGAN PIPE
OUTPOST
[opposite page] Organ
pipe cactuses reach their
northern limit on sunny,
frost-free slopes in Organ
Pipe Cactus National
Monument. | *Laurence
Parent*

HERE COMES
THE SUN
[above] Morning
sunshine highlights
colorful spring flowers in
the dark and forbidding
Kofa Mountains.
| *Jack Dykinga*

DELICATELY
DETERMINED
[right] The first few
needles of an emerging
ponderosa pine seedling
are still bound together by
their seed coat. | *Tom Bean*

CINDER SURVIVORS
[opposite page] Ponderosa
pines emerge from the
seemingly inhospitable
volcanic cinders of Sunset
Crater Volcano National
Monument. | *Bruce Griffin*

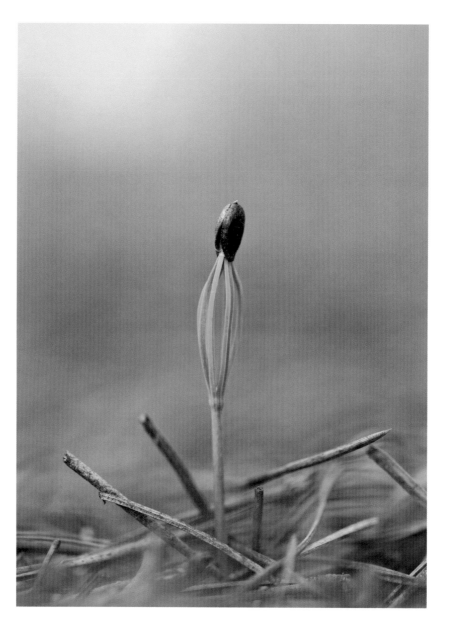

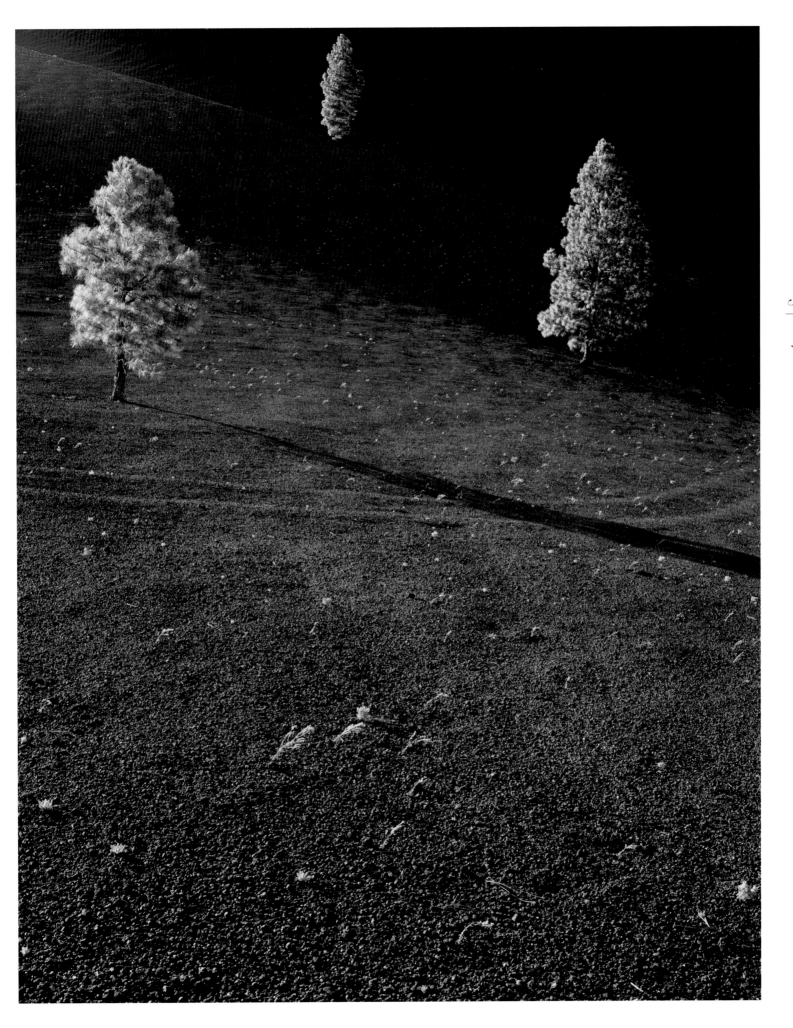

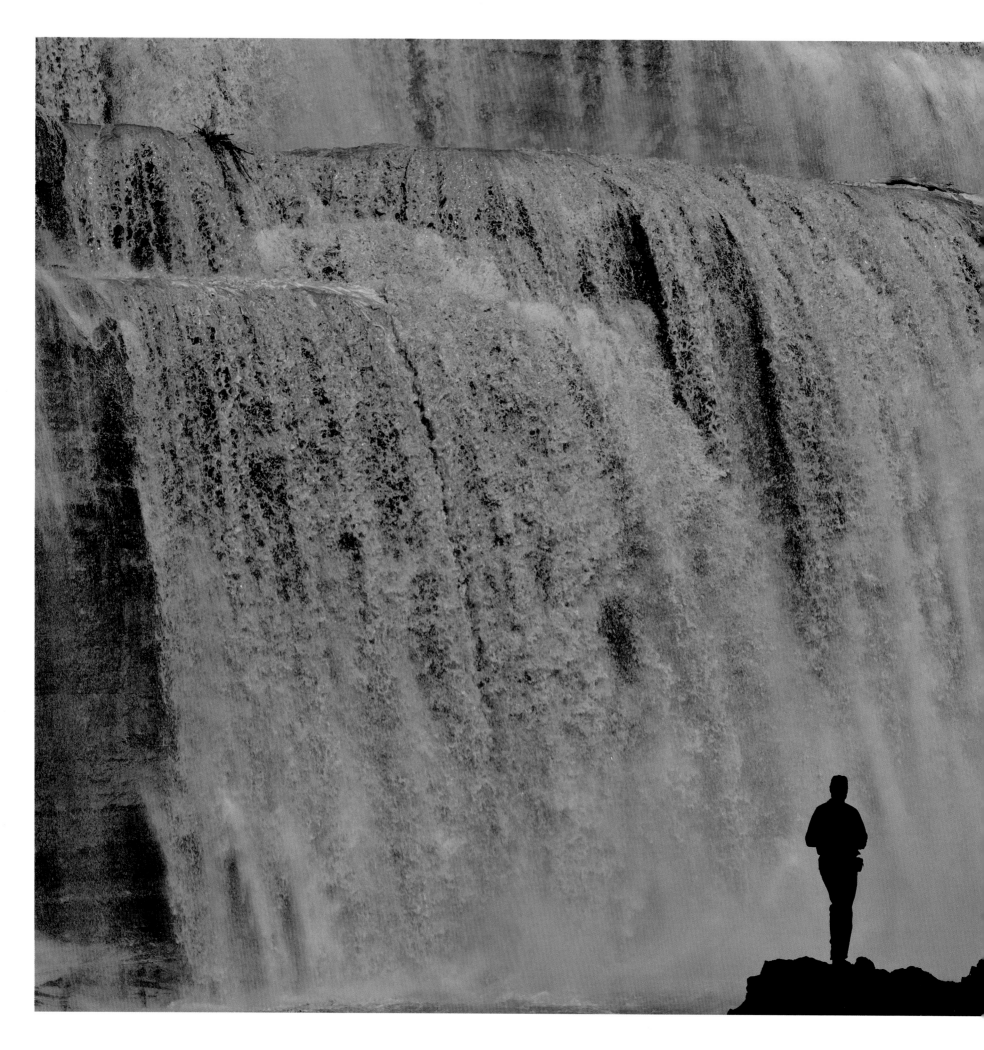

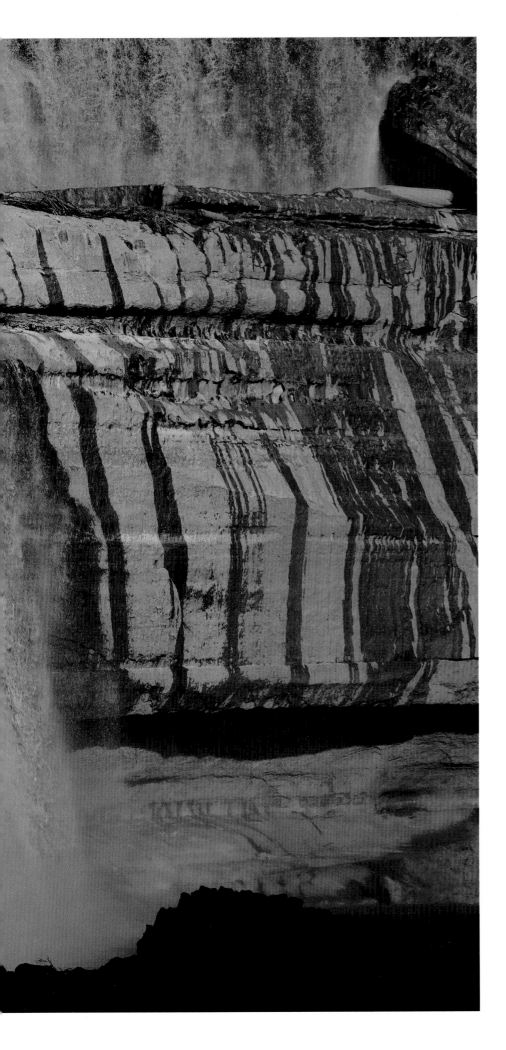

RUSTY RED
[left] Spring runoff
colored by silt from the
Painted Desert flows over
Grand Falls on the Little
Colorado River, Navajo
Nation. | *Tom Bean*

SPRING GREEN
[below] Virginia creeper
winds between stream-
rounded boulders in
Lanphier Canyon, Blue
Range Primitive Area.
| *Jerry Sieve*

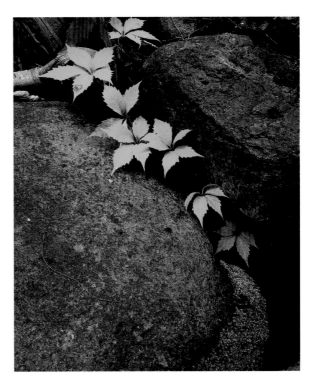

Summer *Weather & Landscape*

Desert rains are usually so definitely demarked that the story of the man who

washed his hands in the edge of an Arizona thunder-

shower without wetting his cuffs seems almost credible.

——*WPA Writers' Program*, Arizona: A State Guide, 1940

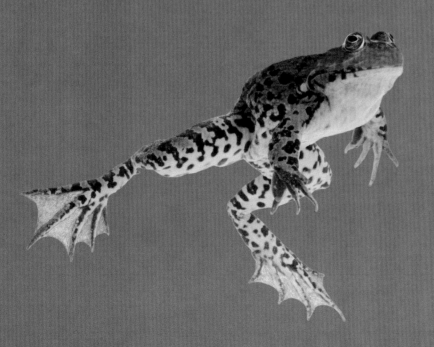

MONSOON STRIKE
Walls of the Grand Canyon surround a sudden downpour from
a summer storm cell during the monsoon season. | *Paul Gill*

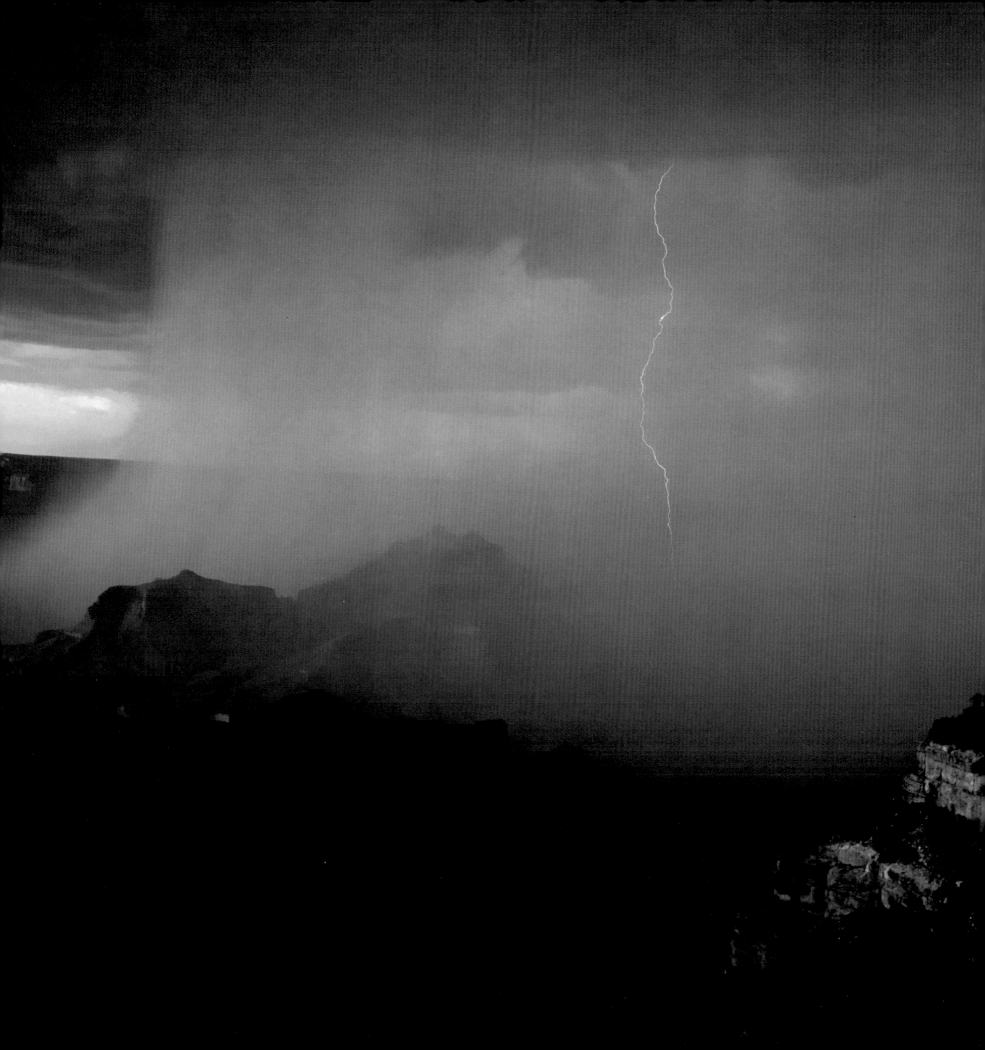

Basin and Range

The crust … has broken into blocks. The blocks are not, except for simplicity's sake, analogous to dominoes. They are irregular in shape. They more truly suggest stretch marks. Which they are.
— John McPhee, *Annals of the Former World: Basin and Range,* 1998

During the Paleogene (about twenty-seven million years ago), the Pacific Plate stopped ramming head-on into what is now Arizona. Instead, it began to drag alongside in a northerly direction, causing the crust here to stretch out to as much as twice its former extent and half its former thickness. This long, slow event mangled the deeper layers of rock. The crust bulged upward and its brittle surface broke into blocks. Some of these blocks dropped down, forming the future basins. Other blocks tilted one of their edges up to the sky and became mountain ranges. These basins and ranges radiated out from the southwest corner of Arizona like ripples on a pond — or like stretch marks.

In Arizona, summer is really *two* seasons. The first is a time of anticipation, as parched earth and thirsty living things await the midsummer rains.

The standard definition of a desert is a region where the rate of evaporation exceeds the rainfall. Nothing could be truer for the first half of summer throughout the state. In the heat of May and June, desert creatures — from spadefoot toads to Arizona twin peaks snails — lapse into estivation, or summer dormancy. Paloverde trees synthesize sunlight in their light green bark, since it is too hot and dry to produce leaves. Anxious about wildfires, the human residents of grasslands, chaparral, and forest lands keep a fretful eye on the weather. It is dry everywhere, but a difference of one thousand feet in elevation can mean a difference of five degrees in temperature. When temperatures in the deserts jump higher than 100 degrees, many folks flee to the mountains.

It is usually after the summer solstice that thunderstorms finally arrive with dazzling spectacles of anvil-shaped cumulonimbus clouds shooting lightning and trailing streaks of rain across the unbounded landscape. The storms occur when humid air flowing up from the south and east meets the dry desert heat, then rises, cools, and condenses. This happens quickly and releases tremendous energy, generating powerful downdrafts that kick up dust and shake the trees. The air feels more and more thick and oppressive as rumbling thunderheads build up before suddenly unleashing torrents of rain that sheet over the ground seeking gullies and washes. Silty water

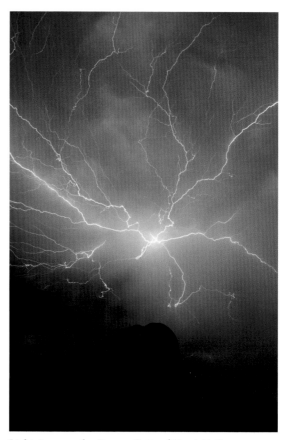

Lightning over the Papago Buttes. | Frank Zullo

floods dry channels in minutes, tumbling rocks and uprooting brush. The pungency of creosote saturates the low deserts and ponderosa pines fill upland forests with their warm butterscotch scent.

Late in the day, the land cools and the cycle winds down. Evenings vibrate with the chirping of crickets in the freshened air. The following day dawns clear and calm, only to heat up and downpour in the mountains by midafternoon and move into the deserts by evening.

The staging of these storms is operatic. Arizona's spectacular landscape is so open that from a distance, storm cells can be seen in their entirety looking like massive purple sea monsters pulsing with lightning and dragging tentacles of rain across the sky.

In the last fifty years, science has been able to translate much of what this melodramatic landscape has to tell us. Geologists now have the language of plate tectonics to explain how slabs of the Earth's crust move like rafts around the globe and, in the process, jostle one another. They say that for the past two billion years or so, the plates under the Pacific Ocean and North America have banged into and moved apart from each other again and again. These movements have pushed up and crumpled the crust of what is now Arizona, intruded valuable minerals into it, pushed layers of it over other layers and allowed it to stretch out again.

Low Desert Landforms: the Basin and Range
Sonoran: Flats and Bajadas

Arizona's low deserts are within a region of level plains and scattered mountain ranges that geologists call the Basin and Range. The basins are as flat as tortillas while the ranges are rugged as old prospectors — steep on their broken side, sloping on the other, craggy on top.

Eons of water, wind, and gravity have battered these ranges. Their ridgelines are toothed, their ramparts formidable. The mountains have shed so much rock and gravel that they are all but buried in up to ten thousand feet of their own debris. In some ranges, erosion has exposed veins of gold, silver, and copper and left placers of gold in streambeds.

Most of the ranges are bare — bare of plants, bare of houses. Many are in the hearts of wilderness areas and wildlife refuges. People live where it is easy to build, either in the basins

The Papago Buttes are a striking sight in the middle of Phoenix — a chaos of strange red sandstone shapes poking up abruptly out of the desert floor. They are the remnant crest of a fault-block mountain that has been weathered into pinnacles and tafoni — water-worn holes in the rock. The people who lived here centuries ago noticed that rays of sunlight pass through the tafoni into a rock shelter. They marked where the light struck on significant days, including the summer solstice.

37
Summer

Transition Zone Eldorado

We descended a slope so steep and dangerous that a mule belonging to Capitán Espejo fell down and was dashed to pieces. We went down a ravine so bad and craggy that we descended with difficulty....
— Diego Perez de Luxan of the Espejo Expedition, 1582-83

In 1583, Hopi people led the Espejo Expedition down four thousand feet from the plateau to the Verde Valley and two thousand feet up again to a mine with "colored ores" near present-day Jerome. Two more Spanish expeditions made the trip there from New Mexico: Captain Marcos Farfán's in 1598 and his commander Don Juan de Oñate's in 1604. Oñate, a man of tough material, toiled all the way across the Central Arizona Highlands and down the Colorado River to the Gulf of California. Although there was copper, silver, and some gold at mines in the Verde Valley (which was named for the green mineral malachite), none of these explorers found it worth the hardship to return.

or on the *bajadas*, which are the fan-shaped slopes that form where mountain gullies funnel gravel to the desert's floor.

Bajadas are a paradise for desert plants, especially in the cooler uplands where six or so inches of rain can soak them in late summer. Less than a month after the rains begin, brilliant orange and crimson bowls of Arizona caltrop shine on these slopes.

In the lowest Sonoran basins, the air can heat up to 120 degrees, the ground temperature may exceed 170, and rainfall is a scant three inches or so. Two North American plants able to thrive under these conditions dominate here — creosote and smoky-gray burrobush. Many animals stay motionless in shade or in burrows all day, moving out only at night.

Mohave: Sweeps and Ridges

The Mohave receives almost no summer rain. Dry lakebeds—*playas*—are common here in the basins below the ranges. The Mohave becomes a blistering oven where heat shimmers the air and shrivels the leaves. Few Mohave plants bloom with much vigor in summer unless a rare rain prompts them, except for the valiant manybristle cinchweed with its scatters of

small golden sunflowers. But what this country lacks in flowers it makes up for with minerals: the Tom Reed and United Eastern gold mines around Oatman were once the richest mines in Arizona.

Chihuahuan: Valleys and Peaks

In the southeastern Sky Islands, many peaks soar a mile above their basins. The loftiest is Mount Graham in the Pinaleno Mountains, which looms 8,000 feet above Safford. Sky Islands are part of the Basin and Range but they are closer together, higher, and more complicated. A mishmash of geologic events left a welter of rock types here,

Bigelow nolina. | *Neil Weidner*

including ash showered by volcanic eruptions twenty-five million years ago.

Summer can be very hot here but it can also be kind — to plants, anyway — because it's when most of the year's ten inches of rain arrives. Rain replenishes the shallow lakes called bolsons where clumps of big sacaton grass grow up to eight feet tall. Tobosagrass responds too, greening semi-desert grasslands sprinkled with Arizona blue eyes, spiderwort, and the Chihuahuan's conspicuous soaptree yuccas. Agaves, sotols, and nolinas burst into bloom in the spiky scrublands, where summer rain takes credit for the great diversity in Chihuahuan cactuses and in its shrubs: allthorn and catclaw, hackberry and barberry, mimosa, mesquite, and Mormon tea. Up in the mountains, Mearns' quail scurry about in oak grasslands; cattails and horsetails surround muddy seeps. Intermittent streams trickle down from the heights to the valleys to temporarily fill the *huecos*, or water-filled potholes—that many creatures need to survive.

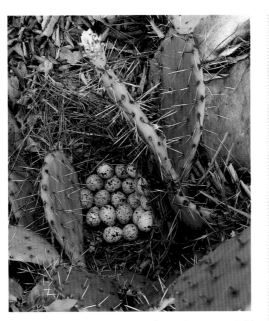
Prickly pear cactus protects quail nest. | *Larry Lindahl*

Central Highlands
Old and Rough

The Central Arizona Highlands are the most rugged of Arizona landscapes: a band of long, high mountain ranges grooved with valleys and puckered with converging stream canyons. This belt of uplands wraps the middle of the state like one of Pancho Villa's *bandoleros*, from the shoulder of the Grand Wash Cliffs north of Kingman to just under the bulge of the White Mountains in the east. Its block-faulted ranges appear to be in the grindingly slow process of splitting off from the northern plateau and toppling into the Basin and Range. Geologists call this part of Arizona the Transition Zone.

Before the construction of Interstate 17, people in Flagstaff say they found it easier to

Trails Across the Highlands

Determined people have always found some way across the Central Arizona Highlands. In 1863, a prospector named James Walker established a trail from the headwaters of the Hassayampa River over the Bradshaw Mountains to Prescott. Stagecoaches and freight wagons followed. In 1874, General George Crook saw to it that a rough wagon road was built between Fort Apache and Fort Verde. The most challenging stretch of today's Arizona Trail, a route from Mexico to Utah scouted by Flagstaff schoolteacher Dale Shewalter in 1985, traverses the highlands from the Mazatzal Mountains to Blue Ridge.

John Strong Newberry

Though valueless to the agri-culturalist, dreaded and shunned by the emigrant, the miner, and even the adventurous trapper, the Colorado Plateau is to the geologist a paradise.
— John Strong Newberry, military physician

Like many other pioneer naturalists, John Newberry was a physician who accompanied military expeditions to take notes and make collections of plants, animals, and minerals of the West. He traveled across Northern Arizona in 1857 with the Ives Expedition, the first white explorers to reach the bottom of Grand Canyon. Newberry's main interest was geology and he was fascinated by the Colorado River's power to carve its course through solid rock. He drew a cross-section of the canyon's layers, and joined another expedition in 1859 to further explore the Colorado Plateau. His reports introduced its geologic wonders to the scientific community and to the world.

travel to Los Angeles than to Phoenix. Crossing the Transition Zone means going against the grain of the land — climbing escarpments, dropping into valleys, descending and ascending the walls of river canyons, and winding around peaks through mountain ranges. There are delightful views of grassy basins from the mountains and of forested mountains from the basins. Leisurely stretches along river valleys lead to tortuous twists through steep, chaparral-clad hillsides. And because of the intricate arrangement of slopes facing different directions at different elevations, a merry confusion of plant communities here further befuddles the traveler.

No matter the difficulty, prospectors have explored the ancient strata of the Central Arizona Highlands since pre-Columbian days. Off-duty Civil War soldiers found placers of gold along streams and veins of gold in the Bradshaw Mountains. From 1876 to 1953, the mines around Jerome yielded silver, gold, zinc, and 3.6 billion pounds of copper.

Of course, minerals haven't been the only resource to draw people here. After the Civil War, cattle and sheep ranchers settled the grassy Tonto and San Carlos basins and the Chino, Verde, and Safford valleys.

Elevations in the Central Arizona Highlands gradually increase from west to east. In summer, the high eastern half with its many cool streams and woodlands is a welcome sanctuary from the hot southern deserts. The grasses are long and lush; the wildflowers gorgeous.

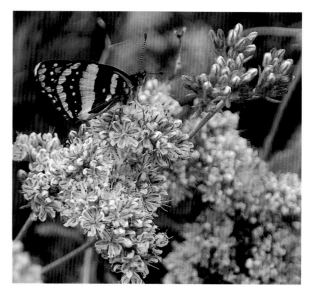

Butterfly sips buckwheat nectar. | *Nick Berezenko*

Much of this eastern half is within the Coconino, Tonto, and Apache-Sitgreaves national forests. Most of the rest lies within the Fort Apache and San Carlos Apache Indian reservations, which were established to end conflicts between prospectors and settlers and the Apache people. Today in these tranquil uplands, Apaches still summon the Ga'an, mountain spirits, for celebrations and rites of passage.

Canyons, Mesas, and Lava Flows

Arizona's plateau and canyon country is a land of vast horizons, with distant features strikingly plain in the crystalline air. The geometry of this landscape is different from that of the southern deserts. Instead of diagonals — tilted fault blocks, sloping *bajadas*, hollowed crests — plateau country is made up of right angles, of level plains and horizontal rock layers eroded into near-vertical bluffs, mesas, and canyons.

The colors here are different, too. Dawns cast a tangerine glow over pastel tablelands; sunsets bronze vermilion cliffs. Limestones, sandstones, and other sedimentary rocks come in clear, light colors in layers of tan, pink, and pale-gray stone utterly unlike the dark, ancient rocks of the southern mountains. This is a blond landscape in early summer, of khaki sands, buff-colored grasslands, and bare, rose-and-yellow slickrock. Strands of summer rains

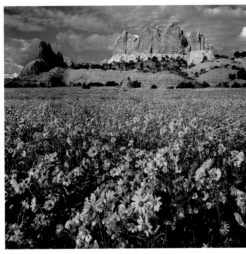

Field of golden crownbeard. | *Robert G. McDonald*

— considered by traditional Navajos to be male rains — appear in this setting as long legs bent at the knees by the wind, moving across the land to the stomps of thunder.

This northeast third of Arizona lies an average of five thousand feet above sea level, on a wedge of the splendid Colorado Plateau. Named for the Colorado River that carves its way down through it to the sea, the plateau encompasses 130,000 square miles of stony country centered on the "four corners" where Utah, Colorado, New Mexico, and Arizona meet.

Black Mesa is in the heart of plateau and canyon country. It is a four thousand-square-mile sandstone plateau tilted up to the northeast. On a map, it resembles a bear's paw coming down from the Four Corners. Flowing water has grooved it with long washes, which divide its southwestern side into promontories like claws. A thousand years ago, the Hopi people built their graceful stone villages here.

Arizona's portion of the plateau seems fairly flat, but its layers of rock are in fact slightly tilted. Erosion nibbles away at their exposed edges to create a series of cliffs and very broad steps leading to the Four Corners. The steps occasionally drape over faults that were caused — like the plateau itself — by an event called the Laramide Orogeny.

The Laramide Orogeny probably took place from forty million to seventy million years ago, although the timing is still under discussion. It's surprising that the event didn't do more damage. In a series of shoves, the Laramide boosted up the plateau at least ten thousand feet.

The Mogollon Rim

A sheer escarpment, the Mogollon Rim runs two hundred miles across Arizona. It is a formidable obstacle, two thousand feet high in some places. In *Call of the Canyon,* Zane Grey — who lived below the Mogollon Rim in a cabin northeast of Payson for a time — described an Easterner's first look down Oak Creek Canyon from the rim:

> *It frightened her — the sheer sudden plunge of it from the heights… And on the moment the sun burst through the clouds and sent a golden blaze down into the depths, transforming them incalculably… Hostile and prejudiced, she yet felt wrung from her an acknowledgment of beauty and grandeur. But wild, violent, savage! Not livable!*

The Colorado Plateau's canyons and mesas are a paradox: They are the work of water in a dry climate. Had it rained here more steadily over the millennia, the landscape would probably be gently rolling — dissolved rather than scoured. Instead, sudden rains sluicing over the landscape in a mad rush to the sea have picked up sand and bits of rock, using them to scrape the land down to its current level and to carve the features we see today.

Here and there along the plateau's southern boundary, volcanoes and lava flows have burst up through the ground to form major features including the White Mountains, Hopi Buttes, and San Francisco Peaks. Some geologists consider these features to be evidence that the ever-extending Basin and Range is dragging the southern edge of the plateau down to join the Transition Zone. Be that as it may, the current southern boundary of the Colorado Plateau is the spectacular Mogollon Rim.

Illustrators often put saguaro cactuses in a classic plateau setting — Monument Valley, for instance. But a saguaro would never make it there because the plateau is too cold for too long in the winter. The most common plateau plant community is the humble piñon-juniper woodland, also known as the "p-j" or "pygmy forest" (or "Great Basin Conifer Woodland" by sticklers who consider it "among the simplest communities in the Southwest.") The p-j is ordinarily found between about five thousand and seven thousand feet on slickrock, cinders, or soil. It has a skimpy understory of big sagebrush and mountain mahogany, bunchgrasses, and various other hardy plants. After the summer rains, this open woodland offers bouquets of milkweed, beeplant, blue flax, scarlet gilia, and penstemon up to the sun. Two highly adapted versions of the last two, Arizona gilia and Sunset Crater penstemon, blossom in the dry, scorching cinders of the San Francisco Peaks volcanic field.

Pretty much everywhere in the plateau country, late summer is a time for yellow flowers. Rabbitbrush and snakeweed bear halos of blossoms and acres of sunflowers burst into bloom. Many different members of the aster or sunflower family thrive in this season, some of them lavender-hued, some of them white or red, most of them yellow.

Flowers of the higher mountains finally come into their own with rainstorms in the second half of summer. Moist clouds form over the mountains first, bestowing the most rain on them. The upland woods are lively with red, pink, and purple penstemons, scarlet gilia,

lupine, rubberweeds, fleabanes, and verbena, among many others. Most appear in patches of sunlight, though there are shady niches of columbine, catchfly, and craglilies. In rare years, patches of Parry agave can shoot their phenomenal flower stalks eighteen feet high, the better to offer their red-streaked yellow flowers to passing hummingbirds.

The plateau has many showy warm-season grasses, which can reach two or three feet in height with plumes of florets, called spikelets, on display. In lower areas of the plateau, sparse grasslands with lots of snakeweed have affinities to the Great Plains to the east or the Great Basin to the north. Rain prompts blooms of blazing star, gaura, and plains evening primrose in late summer grasslands. Drier places sustain combinations of cold-tolerant, evergreen shrubs such as sagebrush and rabbitbrush, shadscale and blackbrush, saltbush and winterfat. Cowpen daisies and prairie zinnia mushroom up where the land has been grazed; tough little buckwheats produce tiny flower puffs on rockpiles.

Strange plants with inconspicuous flowers and segmented or semisucculent leaves tend to thrive in the salty floodplains of the Little Colorado River, Chinle Wash, and drainages in the Arizona Strip. These include greasewood and members of the goosefoot family: burningbush, seablight, iodinebush, and the appropriately named saltlover.

It is nothing short of miraculous that the Hopi people have successfully farmed corn and beans and squash on this quadrant of the Colorado Plateau for more than a thousand years. Their affinity with the land is eloquently expressed in their ancient stone villages, which seem to have grown from the rock itself.

Rainsoaked lizard on agave. | *Nick Berezenko*

Crack-in-Rock

The middle window of Crack-in-Rock's calendar wall marks the first of May, the time to plant corn. The soil has warmed by then, a deep frost is unlikely, and more wild plants are emerging. After several more weeks, the north window indicates the summer solstice, the day when the sun rises at its farthest point north on the horizon, reaches its maximum height at midday, and shines for the longest day of the year. At the solstice, the sun is poised to begin its retreat toward the southern horizon, meaning shorter days and eventually, winter dormancy. The Hopi midsummer ceremony of Niman bids farewell to Katsinam, spirit intermediaries, as they leave the mesas to spend the next six months on the San Francisco Peaks.

ROCK OF AGES
[right] An ocotillo finds a foothold in a precipitous cliff of brittle, colorful quartzite in the Sierra Ancha, Tonto National Forest. | *Tom Bean*

ABRUPT TRANSITION
[opposite page] Sunset casts a ruby glow on a summer rainstorm over the rim of the Sierra Ancha. | *Tom Bean*

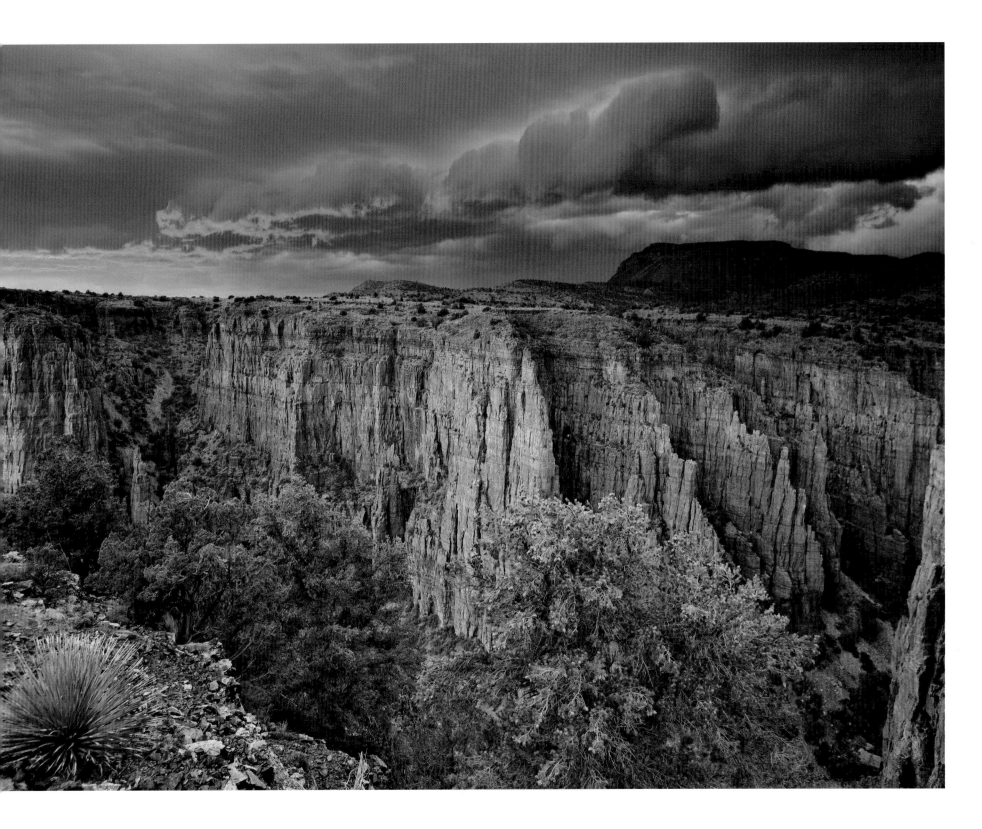

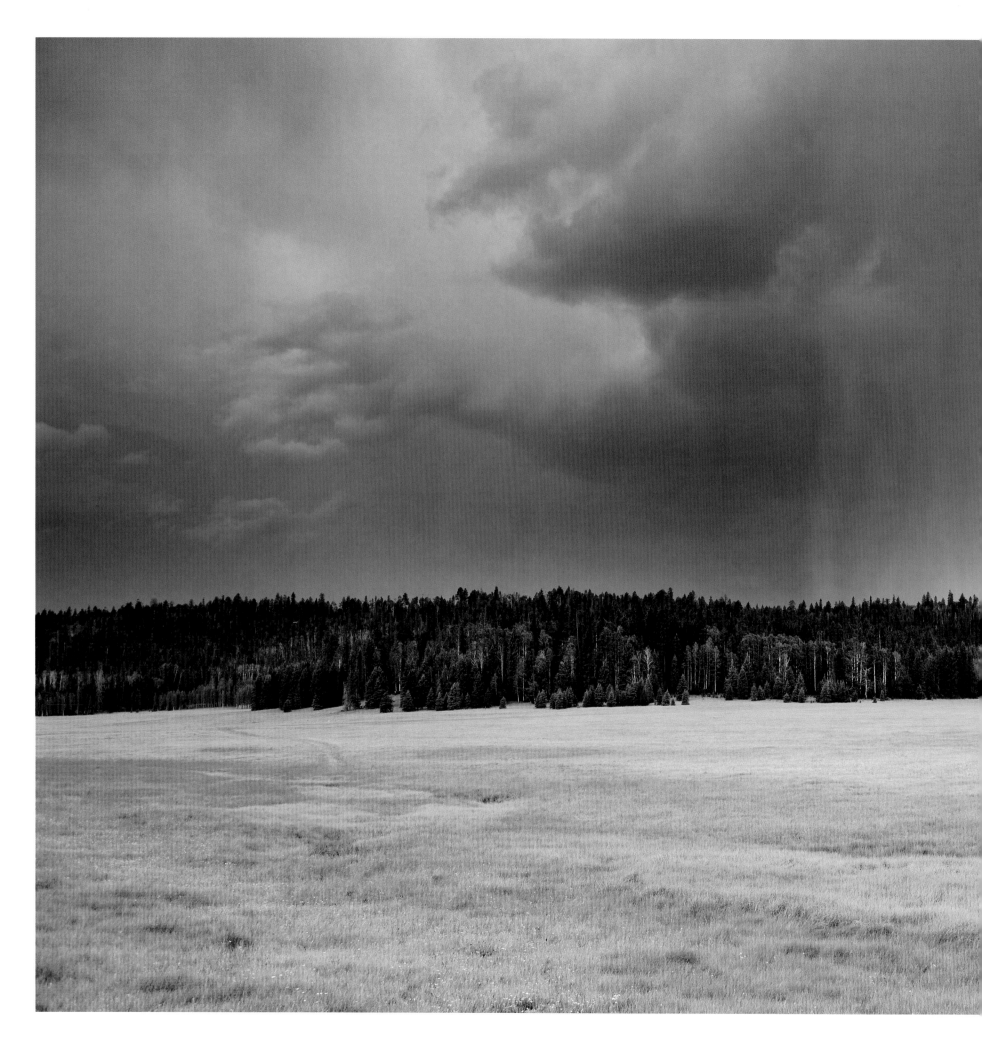

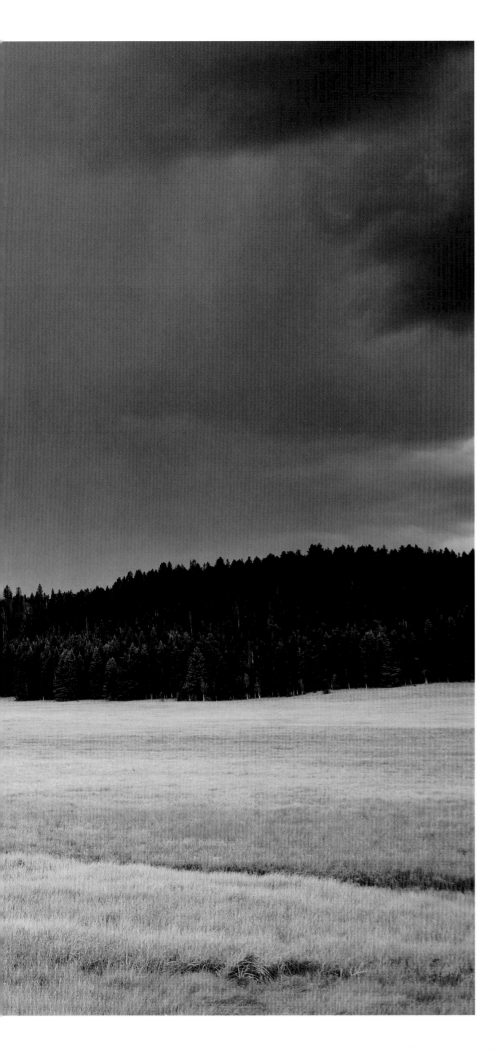

SOGGY MEADOW
[left] Late summer rains result in lush grasses in De Motte Park on the North Kaibab National Forest. | *Tom Bean*

APHRODITE FRITILLARY
[below] This butterfly seeking nectar from mintleaf beebalm is one of more than 330 butterfly species in Arizona. | *Frank Zullo*

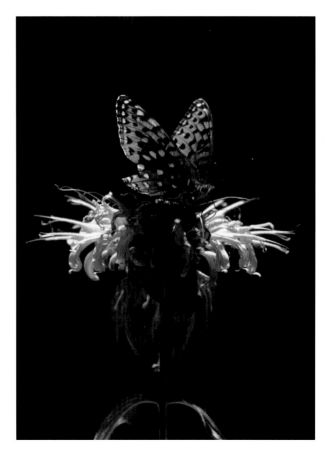

AT RAINBOW'S END
[right] A rainbow arcs through the rainwashed sky over ancient Wukoki Pueblo, Wupatki National Monument. | *Tom Bean*

CLEARING STORM
[opposite page] Beams of light radiate into Grand Canyon as the sun sinks behind a dissipating storm cloud. | *George Stocking*

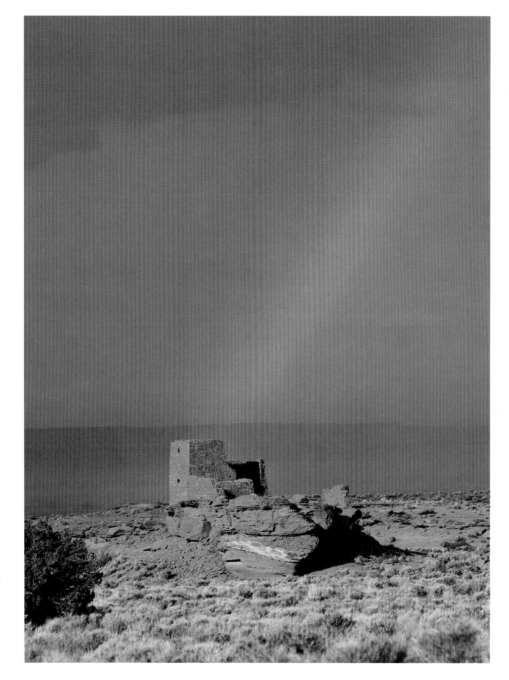

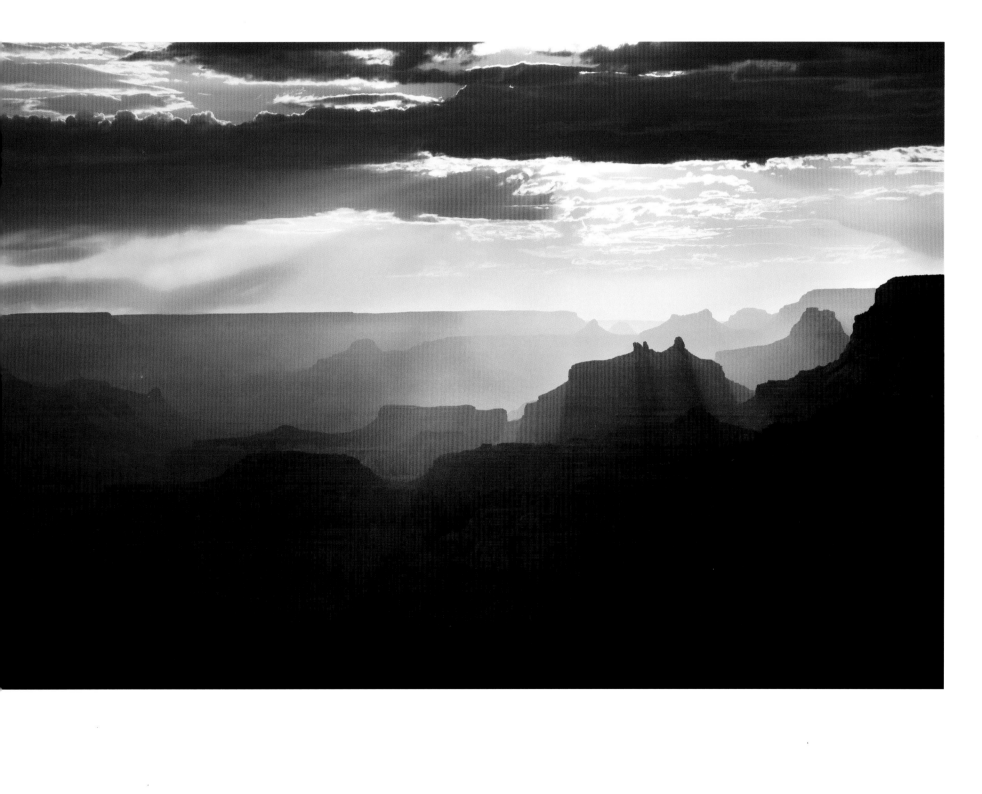

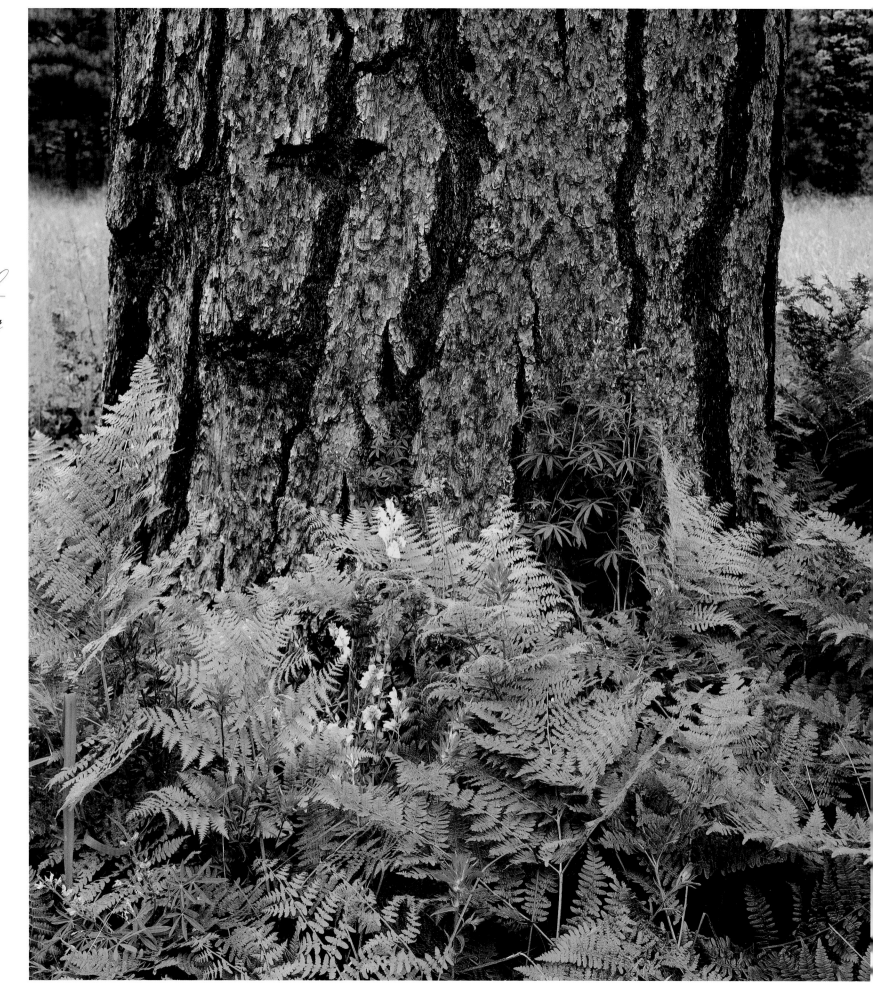

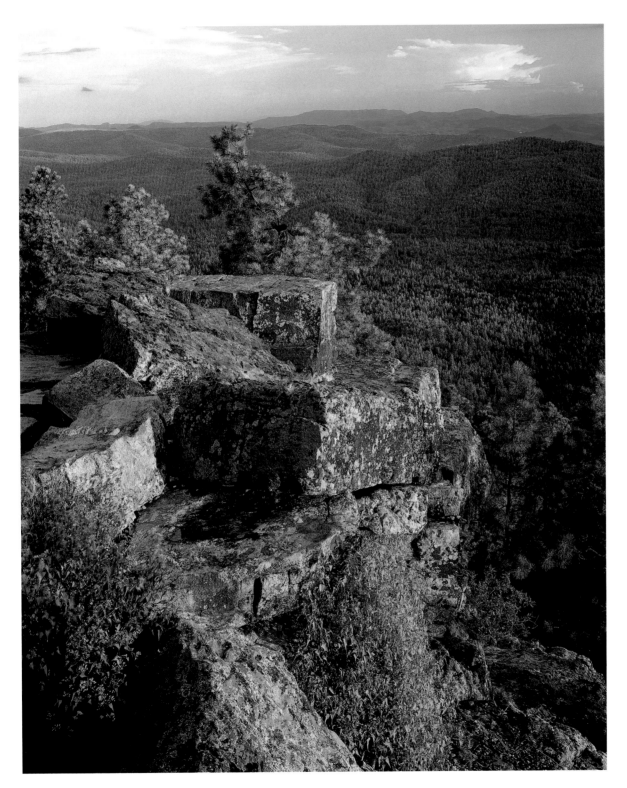

BOUQUET IN
THE BRACKEN
[opposite page] Lupine,
locoweed, Indian
paintbrush, and toadflax
mingle with ferns
beneath a ponderosa
pine, San Francisco
Peaks. | *Paul Gill*

SUNSET VISTA
[left] The rocky lip of
the Mogollon Rim offers
a view over the vast and
rugged Central Arizona
Highlands. | *Jerry Sieve*

Summer

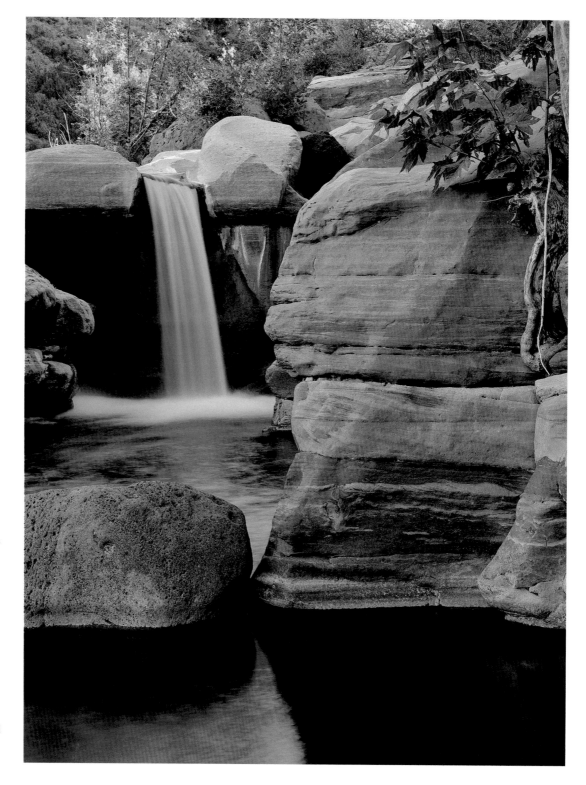

SUMMER
SHIMMERING
[right] Indian Maid Falls
flows over red sandstone
boulders in West Clear
Creek, Coconino
National Forest. | *Nick
Berezenko*

DESERT OASIS
[opposite page]
Maidenhair fern and
golden columbine cling
to the travertine walls of
Fossil Creek in the Fossil
Springs Wilderness.
| *Nick Berezenko*

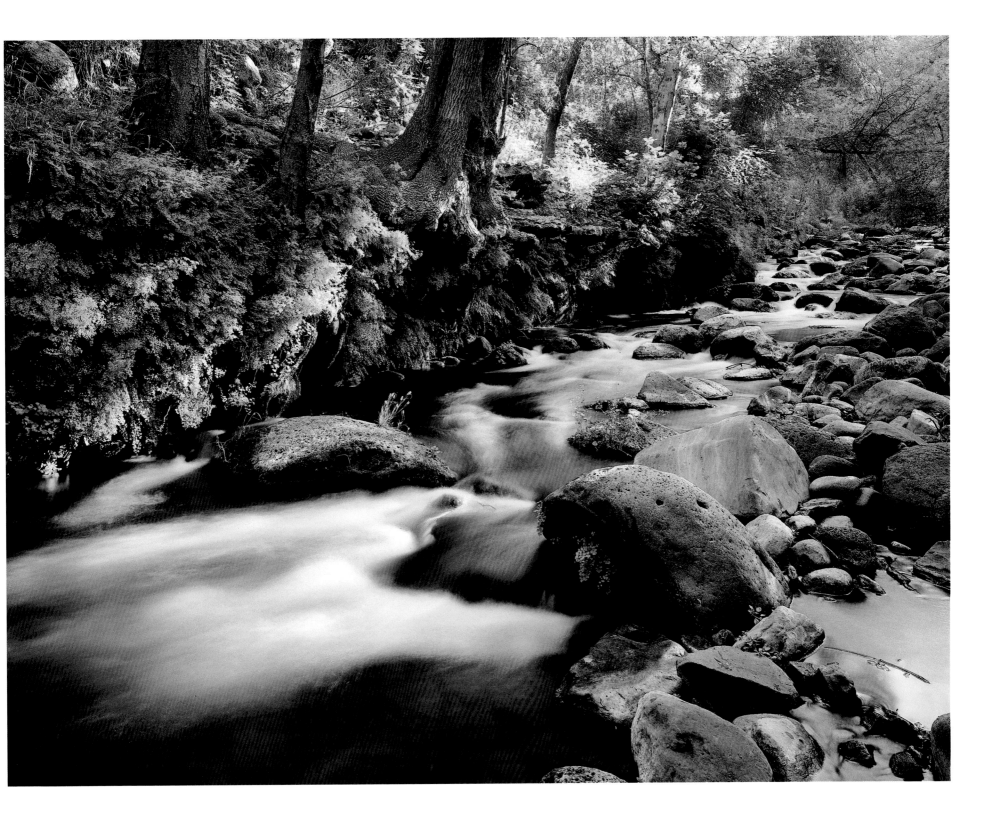

MORNING MYSTERY
[top] Sacred datura buds
open in late afternoon to
attract moths with their
strong, sweet fragrance.
| *Nick Berezenko*

SKY BLUE
[right] Western
dayflowers bloom in the
understory of coniferous
forests when the late
summer rains have
begun. | *Tom Bean*

MIDNIGHT CHILL
[opposite page] Sunrise
after a cold August night
finds frost sparkling on
a meadow on the North
Rim of Grand Canyon.
| *Robert G. McDonald*

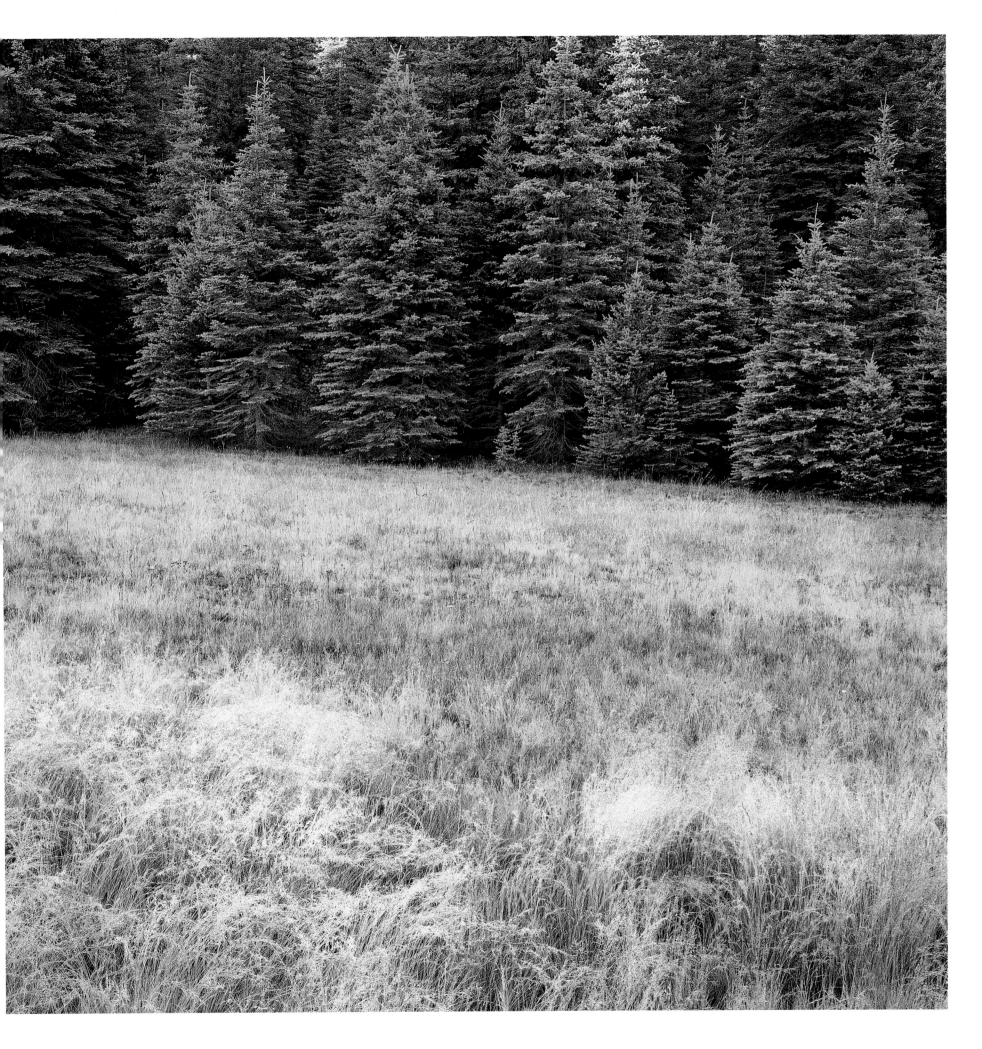

SUDDENLY SEEN
[below] Myriad
mushrooms erupt
everywhere in Arizona's
forests after late summer
rains soak the warm soil.
| *Tom Bean*

NEXT GENERATION
[right] A young conifer
reaches toward the light
in a mature aspen grove
beside Lockett Meadow,
San Francisco Peaks.
| *Tom Bean*

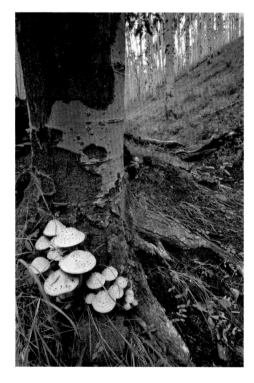

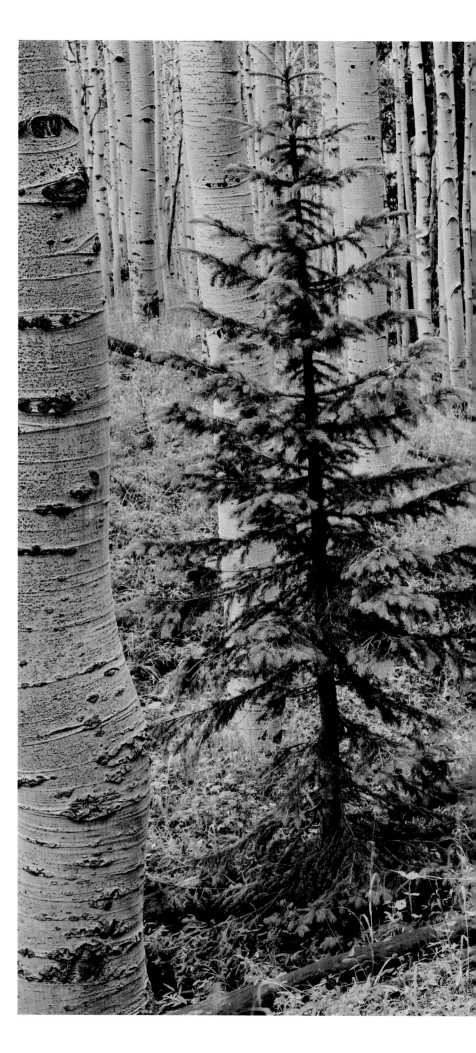

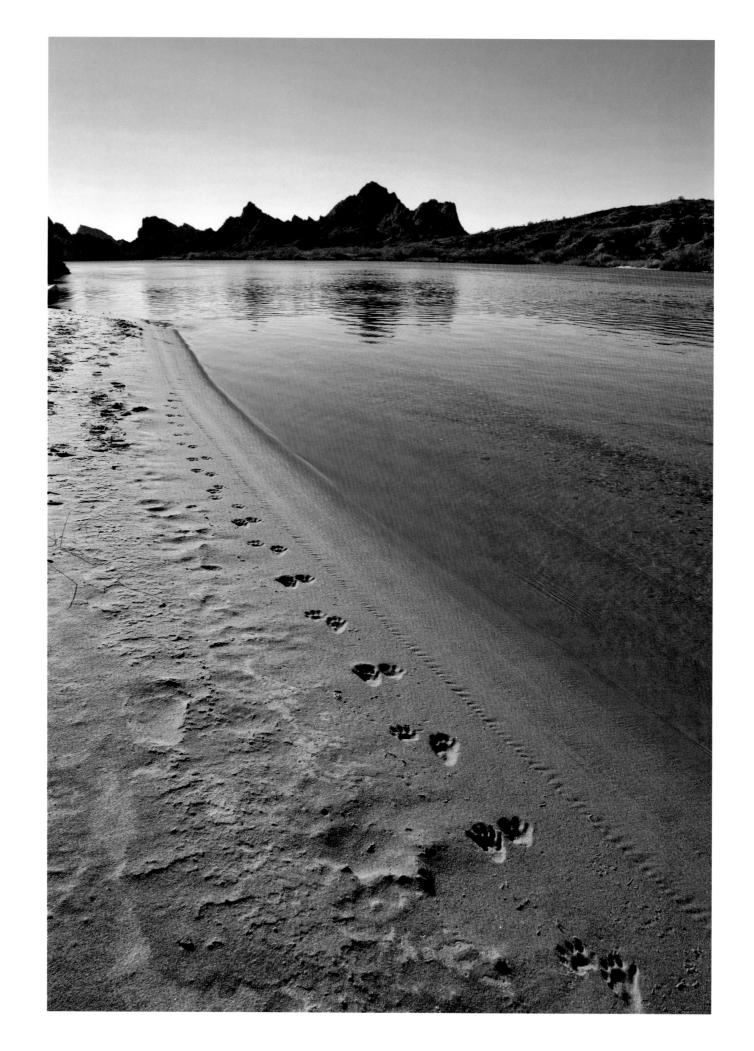

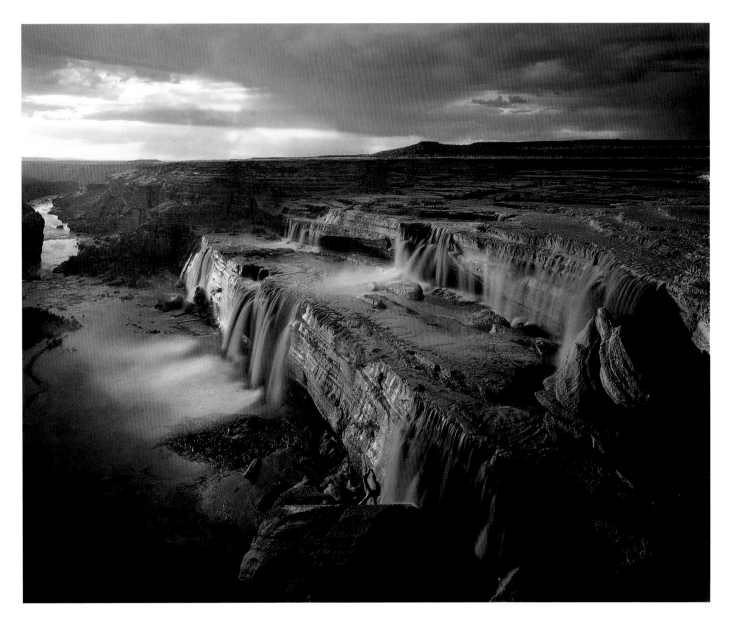

BEACH WALK
[opposite page] Morning reveals the passage of a raccoon alongside the Colorado River, Havasu National Wildlife Refuge. | *Tom Bean*

SUNSET CASCADE
[above] Grand Falls runs rich with sand and silt during the late summer rainy season on the Navajo Nation. | *Robert G. McDonald*

Autumn

Springs, Rivers, & Lakes

In terms of biodiversity, wetlands are disproportionately important in relation

to their size, sustaining ecosystems over a scale that

ranges far beyond the wetlands themselves.

— *Matt Jenkins*, author

MIRROR OF BRONZE
Walnut and willow trees in autumn foliage surround a quiet pond
in Sabino Canyon, Coronado National Forest. | *Randy Prentice*

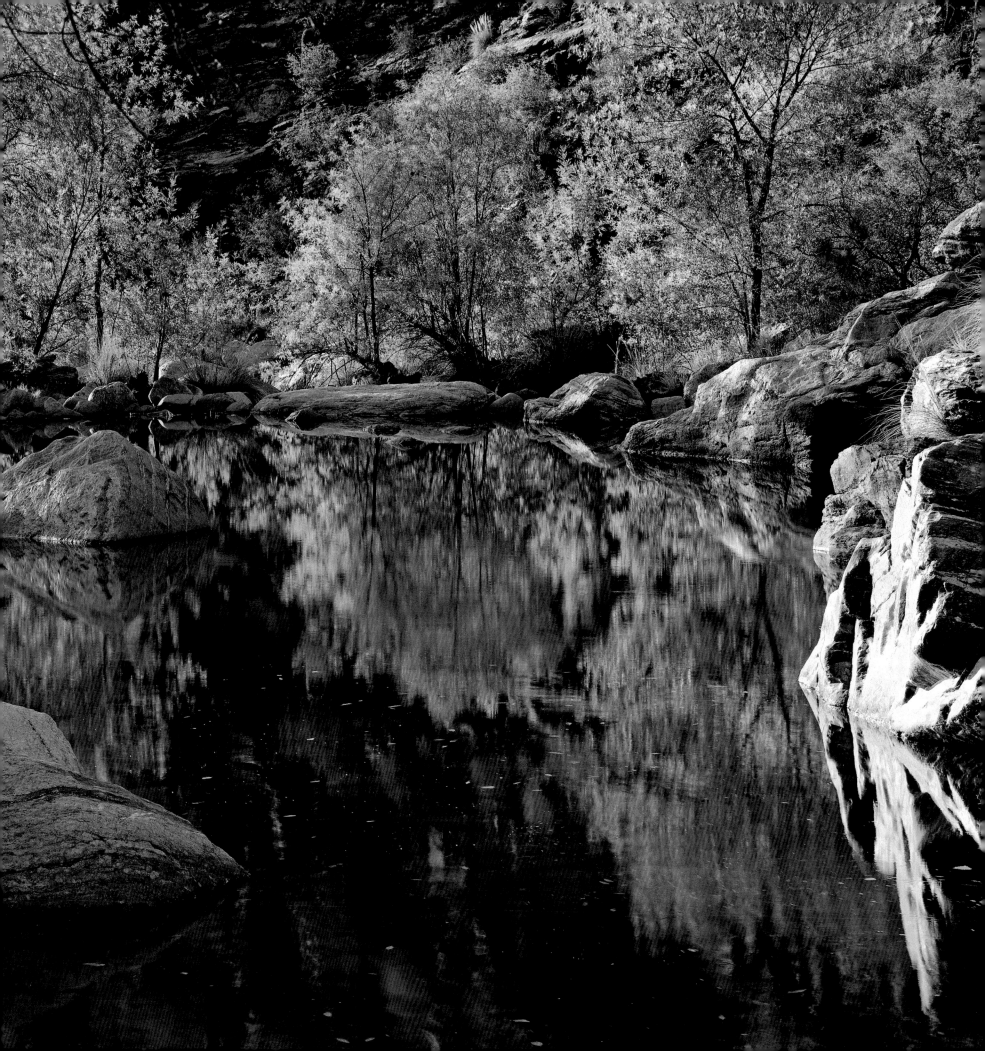

utumn in Arizona seems brief. As the days grow shorter, mornings dawn crisper and the sun traces a lower arc over the southern horizon. Flowers fade and form plumes, pods, and fruits; grasses turn tawny and scatter their seeds. Shrubs are transformed by colors more rich and varied than the pervasive green of summer. Aspens still flutter their leaves but these turn papery and golden, veins visible against the sunlit sky. Portents of winter are everywhere, as elk and deer rub off their antler velvet and vultures gather in whirling "kettles" to begin their migration south.

We see the changes most where there is water, whether it is on the surface or moving underground. Water has such an influence on the shape of the landscape, its plants and animals that we know where it flows even when it isn't there. The landforms and life-forms of canyons and washes speak of streams; both marshes and dry lakebeds harbor wetland plants. Deer tracks lead to springs and seasonal seeps where leafy trees change hue — willows to dark red, sycamores to yellow, cottonwoods to gold. Such places can be seen from afar, bright with the colors of autumn.

Not only can we see where water flows, we can hear it trickling through stones, spattering from falls, roaring through rapids. Our noses know it's there, too, by the musty odor of muddy earth and the sharp scent of fallen, moldering leaves. Even our skin can sense water, in the sudden chill of damp air.

Arizona is divided up by mountains and cliffs and laced back together with streams. The greatest of these is the Colorado River. Its influence is felt in every corner of the state. The Colorado has literally shaped Arizona from its carving of Grand Canyon to its role as our boundary to the west. Most other rivers and their tributaries lead to it, converging in patterns like the branches on a tree. They, too, shape the landscape. The resulting sediments they carry change with the seasons and the Colorado changes color as they do, running green and translucent in dry times and rusty after rains and snowmelt.

Arizona's rivers are vital corridors of migration, paths of movement for foraging animals, songbirds, insects, and plants. Dynamic systems, they are forever flooding or drying up, renewing the soil or carrying away rocks. Their shrubs and trees provide shade and places to

hide, perch, and nest. Mammals, reptiles, and birds from miles around depend on the rivers' water, their insects and fish. Rivers are key to our human story. They have supported native cultures since antiquity and drawn conquistadores, missionaries, trappers, prospectors, soldiers, traders, and settlers.

Streams only tell part of the story of Arizona's water. Quiet pools, springs, marshes, and seeps sustain the greatest diversity of plants and animals in Arizona's varied but ever-arid landscapes. More than one in ten of all of Arizona's plants are found only around springs. Soggy spots host a strange but vigorous community of sedges, cattails, reeds, and bulrushes along with dragonflies, salamanders, frogs, and toads. The springs form where rainfall or runoff percolating down through the ground meets a fault or impermeable layer of stone or clay, and is forced to the surface. Groups of springs can form desert marshes called cienegas. Beavers, too, can engineer wetlands, diverting water from rivers or building dams on creeks.

Biologists use the term "riparian" to describe the plants and animals of riverbanks, wetlands, or springs. In the Southwest, riparian is also used to describe places where there is water only some of the time. Even slopes that are snowy in winter are considered riparian by some, since what grows there needs so much moisture. Even though less than one percent of Arizona is riparian land, about one-third of all bird and plant species in Arizona depend upon the state's rapidly disappearing riparian habitat.

Low Desert Oases
Sonoran: Leafy Havens

Fall in the desert is mild, cool enough for desertbroom to finally blossom. The hours of sunlight grow fewer, the growth of most plants slows down. Summer rains are over, the rains of winter yet to come.

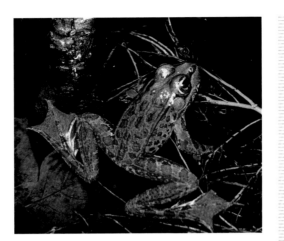

Lowland leopard frog. | *Tom Danielsen*

Mountain Men

At twelve we started up Red [Colorado] River, which is between two and three hundred yards wide, a deep, bold stream, and the water at this point entirely clear.… The timber of the bottoms is very heavy, and the grass rank and high. Near the river are many small lakes, which abound in beavers.

—James Ohio Pattie, pioneer

63
Autumn

Rivers first brought Anglos to Arizona. After winning independence from Spain in 1821, Mexico opened the region to outsiders. For the next twenty-five years or so, intrepid mountain men headed west each autumn to trap beavers along Arizona's rivers. For a time there must have been hundreds of them trapping, trading with the native people, and panning for gold. The records of them are few, the legends many. One young man did publish an account of his adventures: James Ohio Pattie. He and his father Sylvester were among the first mountain men to follow what Pattie referred to as the "Helay" — the Gila River — in 1824.

Military Expeditions

We encamped on an island where the valley is contracted by sand buttes in what had been very recently the bed of the [Gila] river. It was overgrown with willow, cane, Gila grass, flag grass, etc. The pools in the old bed of the river were full of ducks, and all night the swan, brant, and geese were passing…
—Lieutenant William Hemsley Emory, Kearny Expedition, 1856

The wanderings of mountain men tapered off in the 1840s, but Arizona's rivers became routes for military expeditions when war broke out with Mexico in 1846. With mountain man Kit Carson as guide, Colonel Stephen Watts Kearny led a force west along the Gila, mapping and making notes for a route to California. Former trappers Antoine Leroux, Paulino Weaver, and Baptiste Charbonneau (son of Sacagawea) guided Captain Philip St. George Cooke and the famous Mormon Battalion into southeastern Arizona and up the San Pedro. These and other expeditions had numerous dustups with the ferocious bulls abandoned by fleeing Mexican settlers.

But everyone knows it doesn't rain very much in Arizona's deserts anyway. The lower basins receive an average of only four to eight inches of rain a year. About ninety percent of it evaporates before it can replenish the groundwater that people and plant communities need. Fortunately, the desert mountain ranges receive sixteen to thirty inches of annual rainfall. Streams flowing down these mountainsides converge into rivers that soak into the ground while sustaining life along their banks. It's easy to see why desert rivers are so important.

The Gila River rises just across Arizona's eastern boundary in the cool mountain forests of New Mexico. It is a desert river by the time it reaches Arizona, a verdant ribbon of life flowing through dry, rugged country cloaked in chaparral, wispy grasslands, and desert scrub. Many creeks wind down from the surrounding highlands to meet it, their streamside plant communities making lines of green, twisting through stony foothills. West of

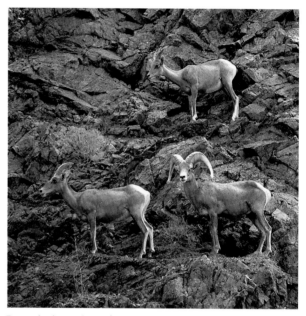

Desert bighorn sheep. | *Neil Weidner*

Guthrie, the San Francisco River adds its volume and velocity as the Gila carves its way through the Black Hills in the steep-walled Gila Box. Myriad birds twitter in the mesquite bosques and cottonwoods at water's edge, while up above, desert bighorns clamber on pale conglomerate cliffs.

The Gila broadens out in the Gila Valley where pioneer James Ohio Pattie saw "musquito" trees, their sweet pods dangling in autumn. The river pauses at Coolidge Dam to form San Carlos Lake, shining translucent blue within the ancient granite of the Mescal Mountains. Below the dam, the Gila traces the edge of the Needles Eye Wilderness where slickrock side canyons join its narrow gorge through tilted layers of limestone. As it presses on toward the Colorado River, skirting below Phoenix and looping around Sonoran Desert

National Monument, the bed of the Gila — dry for much of the year — still has pockets of riparian plants and trees.

The Bill Williams River makes its way to the Colorado River from the confluence of the Big Sandy and Santa Maria rivers north of Wickenburg. The Bill Williams is a living band of green where warblers, flycatchers, and tanagers swoop among the willows. Deer and bobcats roam along it and beavers glide through the waters. This river is detained in a reservoir, Alamo Lake, before cutting through the Swansea and Rawhide Mountains wilderness areas.

Western tanager. | *G.C. Kelley*

Approaching the Colorado River, the valley of the Bill Williams River widens to embrace the colorful autumn canopy of the largest remaining natural cottonwood-willow forest in Arizona. Beyond, a cattail marsh fills the river's mouth, a haven for resident and migratory birds, from coots to cormorants and the rare, endangered Yuma clapper rail. This marsh, together with the bottomland forest and surrounding hills, makes up the Bill Williams River National Wildlife Refuge. In its mingling of Sonoran and Mohave communities, the refuge sustains incredible numbers of plants and animals — three hundred forty different bird species and a host of mammal, reptile, amphibian, and native fish species. At least sixty-three species of butterflies and skippers have been spotted here.

Mohave: Nooks and Sanctuaries

Here and there throughout the Mohave, the occasional seep or spring supports a range of plants and wildlife. Paloverde and teddybear cholla cling to slopes grazed by bighorn sheep in the Mount Nutt and Warm Springs wilderness areas, where streams trickle down stony washes lined with willows, cattails, and other streamside plants.

Mohave plants and the creatures that depend on them also follow the Colorado River into the depths of the Grand Canyon where they mingle with Great Basin plants that reach down the river from Utah.

Akimel O'odham means River People. For many centuries, their lives centered around rivers: the Salt, Gila, Santa Cruz, and San Pedro. They gathered wild plants and hunted along the banks, and dug channels from the rivers to their corn and bean fields in the floodplains. Although stretches of the Gila run dry now, the Akimel O'odham people still tap it for irrigation. They revere the Gila to this day.

66

Autumn

"Old Bill" Williams, said to have once been a missionary among the Osage, became a famous mountain man who trapped beaver throughout the American Southwest and Rocky Mountains. Like several other mountain men who had explored Arizona — among them Kit Carson and Antoine Leroux — Williams later served as a scout and guide on military expeditions to explore and map the West and document its resources.

Chihuahuan: Corridors of Migration

Rivers provide sanctuary down in southeast Arizona, as well. With their arches of golden-leaved cottonwood boughs, rivers of the Chihuahuan Desert have been compared to cathedrals. The San Pedro and Santa Cruz rivers both run north from the border with Mexico, providing a lifeline for the bats and many birds that migrate to and from the south. These rivers and their tributary creeks host ninety percent of the bird species in southeastern Arizona — at least twenty-two of them threatened or endangered including the exquisite rose-throated becard with its high, haunting whistle.

Streams originating in the Sky Islands send a network of cypress and sycamore trees fanning across the basins. Ash, alder, hackberry, and walnut mix along brooks in the higher elevations, turning russet and tan in the fall. Bird enthusiasts from all over the world visit the riparian canyons of Southeastern Arizona to observe brightly colored, foot-long elegant trogons in the leafy canopies of sycamore trees from April to October.

Springs, marshes, and seeps appear in some surprising places in the deserts. In Organ Pipe Cactus National Monument near

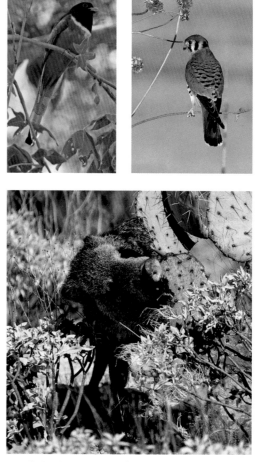

[top, left] Elegant trogon. | *C. Allan Morgan*
[top, right] American kestrel. | *Paul and Joyce Berquist*
[above] Javelina eating prickly pear. | *G.C. Kelley*

the border with Mexico, seven springs issuing from the cracked granite of the Quitobaquito Hills have created a lush oasis around a pool inhabited by mud turtles and the very rare Quitobaquito pupfish. There, cottonwoods shade and shelter mule deer, javelinas, more than two hundred bird species, and 271 kinds of plants.

Central Highlands
Where Rivers are Born

Autumn in the Central Arizona Highlands is beautiful and complicated, as millions of shrubs and trees change color, from high mountains to low valleys and along canyons in between. Black bears fatten on acorns, currants, and cactus fruit in the upper reaches; bluebirds form flocks and move down to lower grasslands. Great blue herons move lower, too, or take off farther south.

There are lots of springs, streams, and small lakes in the Central Arizona Highlands. The ancient impermeable rock layers trap and channel rainfall and snowmelt, as do the young volcanic flows around Prescott and in the Chino Valley. Where the Mogollon Rim has split open the side of the Colorado Plateau, springs trickle from between layers of sedimentary stone just above the valley floor.

Rushes, sedges, and spikerush grow along the edge of water at all elevations, but there the similarity ends. Sycamores, willows, and cottonwoods shade streams and wetlands below 3,500 feet, while above 7,000 feet chokecherry, box elder, willow, and Rocky Mountain maple trees grow among the pines and firs of the forest. Diversity is greatest in between the two, combining what is above and below as well as horsetails and blackberries, alder and walnut, velvet ash and hybridizing swarms of oaks. Steep canyon creeks under the Mogollon Rim are named for these trees: sycamore, oak, and cherry.

With its midsection around 3,300 feet in elevation, Verde Valley has always been a good place to live, easy to cultivate in summer and good for hunting in winter. Archaeologists find many ancient villages here, from clusters of Basketmaker pithouses to the classical pueblos of Tuzigoot and Montezuma Castle. They say people farmed there in the floodplain of the river. They gathered wild plants nearby and trekked or traded upslope for piñon nuts, downslope for agaves. They settled around the red buttes of Sedona, too, leaving petroglyphs on sandstone cliffs.

The Verde River flows year-round through much of its broad valley. One long stretch of the Verde is Arizona's only designated "wild and scenic" river. Below Tuzigoot, the Verde River Greenway conserves a rare patch of cottonwood-Goodding's willow gallery forest. It supports a very high density of breeding birds, including southwestern willow flycatchers

The Ives Expedition

Partridge ravine widened as it was descended, till it became a beautiful valley [Chino], covered with grassy slopes and clumps of cedars.... Among the rocks along the base of the bluffs many pools were discovered.
— Lieutenant Joseph Christmas Ives

In 1857, the U.S. sent Ives to establish the head of navigation on the Colorado River and to determine its usefulness as a supply route for an Army detachment set on enforcing federal laws in Utah. The Ives Expedition steamed up the Colorado River in a bright red, 54-foot paddle-wheeler until it struck a rock in Black Canyon near present-day Hoover Dam. Ives and some of his party headed overland to Fort Defiance along a meandering route, making a detour along the way to the bottom of the Grand Canyon via Diamond Creek and then through a bit of the Verde Valley.

Frosty Gambel oak leaves. | *Robert G. McDonald*

and southwestern bald eagles. Mule deer, javelinas, coyotes, and raccoons prowl the gallery, visiting the river habitat of weird-looking endangered fish — spikedace minnows, Colorado squawfish, and razorback suckers — and lowland leopard frogs, river otters, and beavers.

Lonesome Valley below Prescott is also wide and temperate, but the Agua Fria River runs only intermittently. There are fewer springs, and upland streams are captured in small reservoirs around Prescott. These are pretty little lakes, especially Lynx Lake, with its encircling footpath skirting alligator junipers and gambel oaks with twisted trunks and branches held out like dancers. There are lakes among the knobby Granite Dells as well: Watson, Willow Creek, and Granite Basin lakes.

At the eastern end of the Central Arizona Highlands, the scene is much different. The elevation is higher, the landscape more wooded. The White and Black rivers and their tributaries flow through a landscape much less settled than does the Verde. This is Apache country, wooded and mountainous, a remote place of creeks and broad grassy valleys and chaparral-clad slopes. Roads — where there are any — twist and turn. The White and Black rivers converge in the two-thousand-foot-deep Salt River Canyon. The walls rise so steeply that the band of green along the river is very narrow indeed. To the south, mountains and valleys become drier and farther apart as they transition to Basin and Range.

Plateau Country
Vital but Fugitive Waters

Autumn is as unpredictable as spring in the plateau and canyon country. Summer rains usually continue through August, but it can be dry and warm. Snow can fall as early as September, with weeks of mild, sunny weather to follow. In general, plants and animals cope with this uncertainty by readying for winter based on day-length, not on current conditions.

The vigorous growth that accompanies summer rains makes for a riot of color as leafy trees, shrubs, and even perennial wildflowers change hue in the fall. Elderberries and hawthorn fruit ripen and grasses become straw-colored fountains, their stalks nodding heavily with seed heads. Pygmy nuthatches form flocks and comb ponderosa pines for food, roosting together by the dozens in trunk cavities to keep each other warm.

Tanagers take off for Mexico and bull elk bugle defiantly at dusk, anticipating the rut.

Arizona's plateau country has few rivers, even though it receives much more rain and snow than the southern deserts. The rock layers at its surface are mostly fractured limestone and porous sandstone, both poor at preventing water from disappearing into the ground. Of course there is the Colorado River, which flows from the Rocky Mountains through four states before entering Arizona, picking up volume along the way. But the chief river actually born in Northern Arizona is the muddy Little Colorado. Together with its tributaries, it drains 26,000 square miles as it traces an arc around the Painted Desert, nibbling at the feet of those otherworldly russet, beige, and cocoa hills.

For much of its 340 miles, the Little Colorado River lazes through grasslands and scrub on a more-or-less level course, its waters generating a salty floodplain plant community populated mostly by the goosefoot family. It vanishes into its sandy channel below Winslow most of the year, reappearing only in a few pools or brief stretches until it nears the end of its journey. It reappears seasonally — after summer thundershowers and with snowmelt in spring — sloshing through its shallow bed to pour what looks like coffee with cream over Grand Falls northwest of Leupp. Twelve miles from the bottom of the Grand Canyon, in its own tortured, cliff-bound gorge, the often dry course of the Little Colorado passes mineral-rich Blue Springs and the riverbed fills suddenly with milky blue water.

Desert springs make much of the life in canyon country possible. Long isolated from the others, each spring has its own, distinctive community of plants and animals, often hundreds of times more concentrated than in the dry surroundings. The Hopi villages at the toes of Black Mesa have been sustained by the springs below their villages for centuries.

Autumn is a beautiful time in the mountains along the southern edge of plateau country, with early snows on the highest peaks above shawls of lemon-, orange-, and rose-colored leaves. There are springs and seasonal creeks on these volcanic heights, and snows that persist for months. Relieving the dark monochrome of pine, fir, and spruce, aspen groves turn color in patches while maples spill red down the draws. Lakes form on the lava flows surrounding the mountains. Some fill naturally, but many are impounded. Coyotes and mule deer leave damp tracks along their marshy shores.

Spanish Missionaries

In the cañadas at this place [Oraibi] there are many peach trees; and though the soil is sterile, since no grass grows, nor any other tree than the peaches they have planted, it is well cultivated, and on the very border of the spring of water I saw some gardens or enclosures containing onions, beans, and several other kinds of garden-truck which have evidently cost much labor to produce.
—Father Francisco Hermenegildo Tomás Garcés

69
Autumn

Missionaries settled in Arizona after the Spanish military expeditions of the 1500s. Franciscan missions founded at Hopi in 1629 ended with the Pueblo Revolt of 1680. Italian Jesuit Eusebio Francisco Kino founded several missions along the San Pedro and Santa Cruz between 1687 and his death in 1711. The area between north and south was basically terra incognita until Franciscan Francisco Garcés visited the Yavapai people in central Arizona in 1774. In 1776, he explored north along the Colorado River to the Mohave River, then went on to meet the Havasupai and Hopi people.

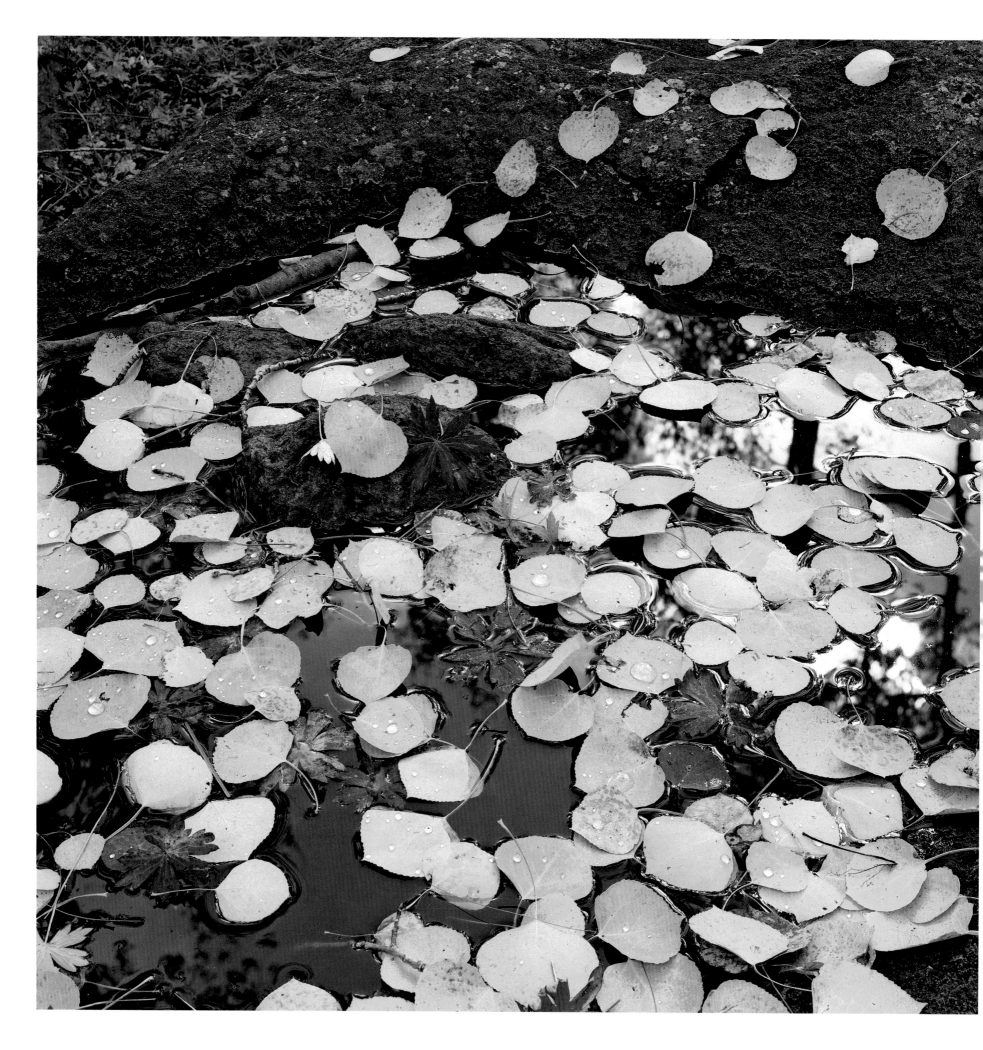

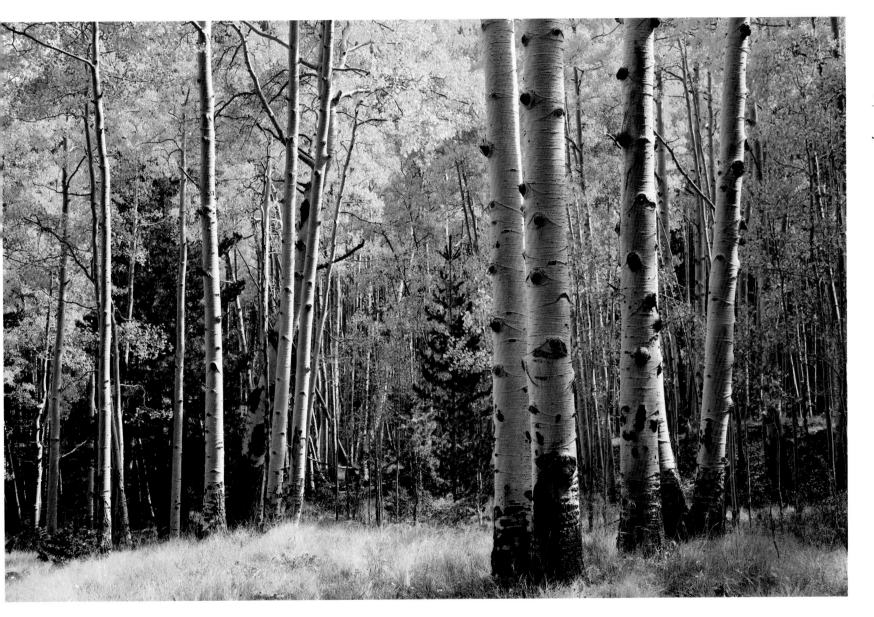

AFTER THE FALL
[opposite page] A rainwater pool collects fallen aspen leaves in the Coconino National Forest above Flagstaff. | *Jerry Sieve*

GLOWING LIGHT
[above] Autumn sunlight warms the grassy floor of an aspen grove on the San Francisco Peaks. | *Tom Bean*

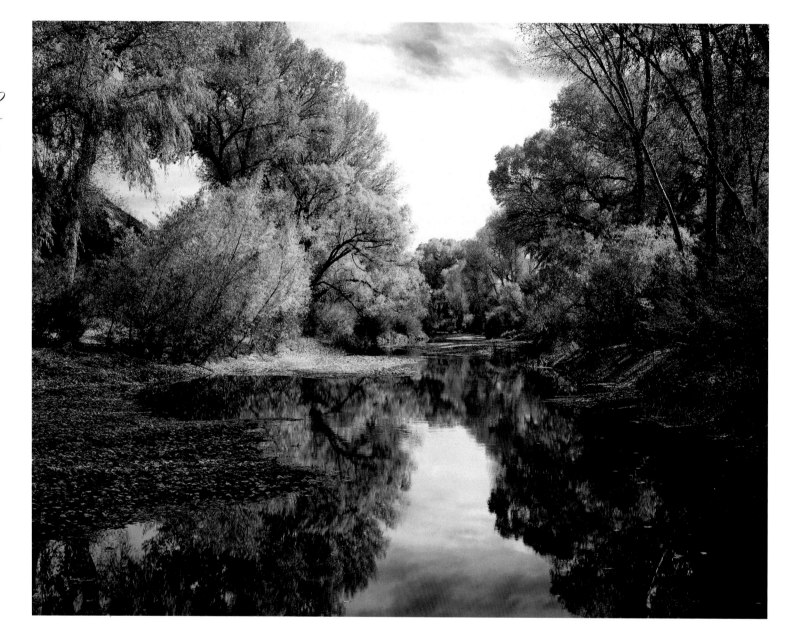

AVIAN AVENUE
The Fremont
cottonwoods and
Goodding willows of the
San Pedro River provide
habitat for millions of
migrating birds. | *Tom
Danielsen*

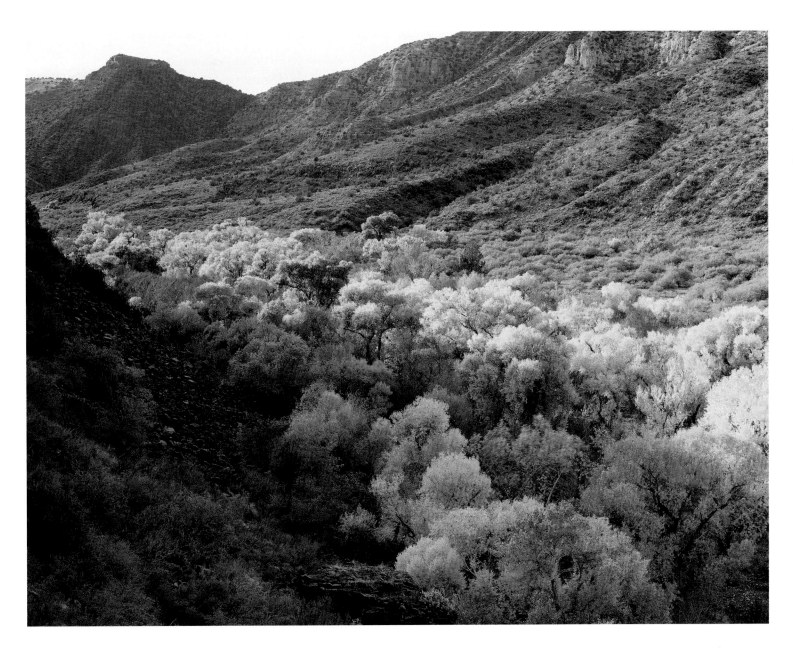

FLUTTERING
CANOPY
Sycamores and
cottonwoods fill the
drainage of Sycamore
Canyon near the Verde
River in the Prescott
National Forest. | *Richard
K. Webb*

Autumn

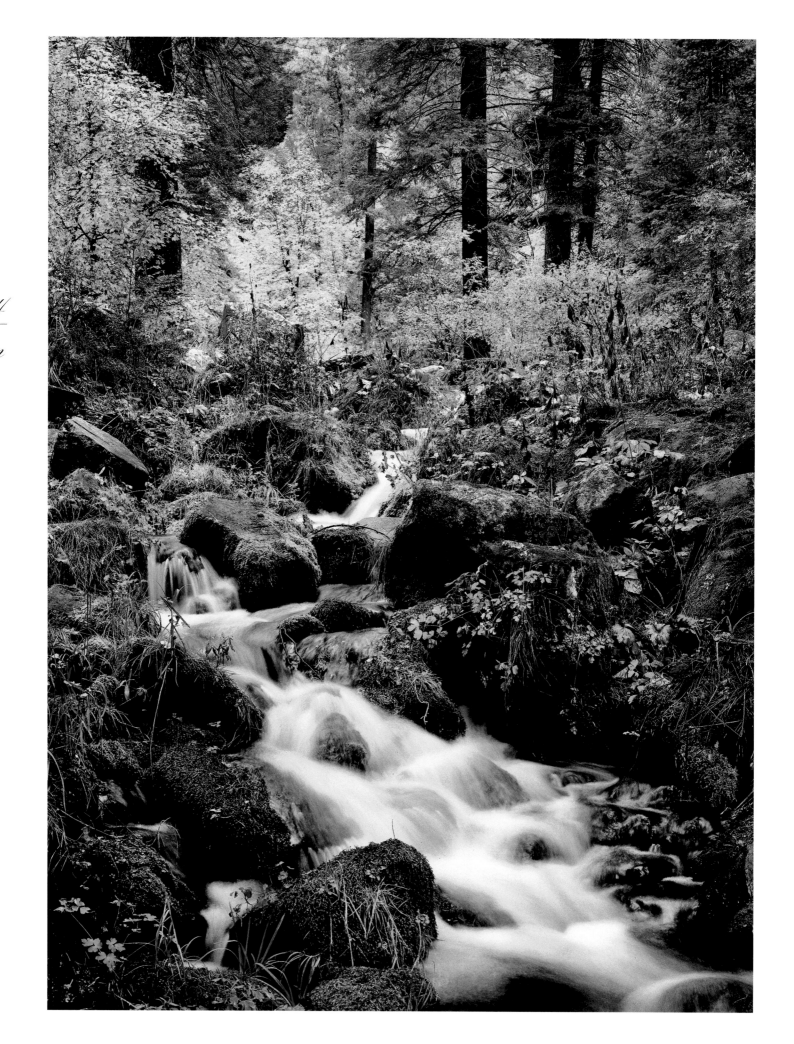

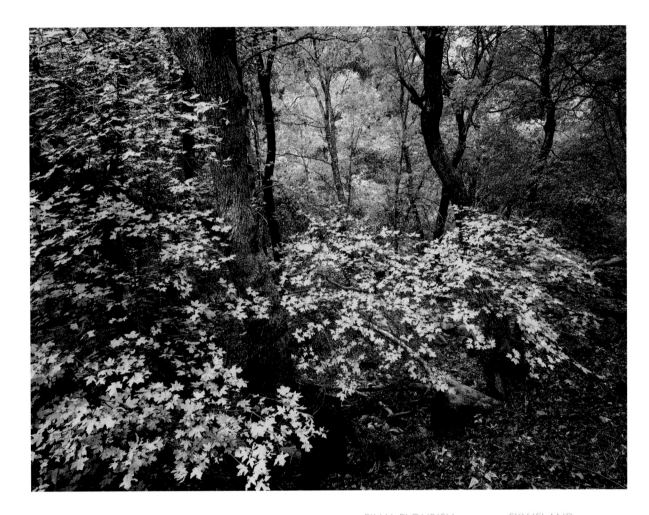

FINAL FLOURISH
[opposite page] Leaves, mosses, and mountain streams reach their full glory in the last days of autumn on the Mogollon Rim. | *Nick Berezenko*

SKY ISLAND SPLENDOR
[above] In fall, bigtooth maples transform Miller Canyon in the Huachuca Mountains of Coronado National Forest. | *Tom Danielsen*

WHEN GREEN
IS GONE
[right] Maple leaves lose
chlorophyll as nights
grow longer, unmasking
their brilliant oranges
and reds. | *Jerry Sieve*

LIFE ZONE OVERLAP
[opposite page] Bigtooth
maples share a cool
mountain canyon with
yuccas, Huachuca
Mountains. | *Jack
Dykinga*

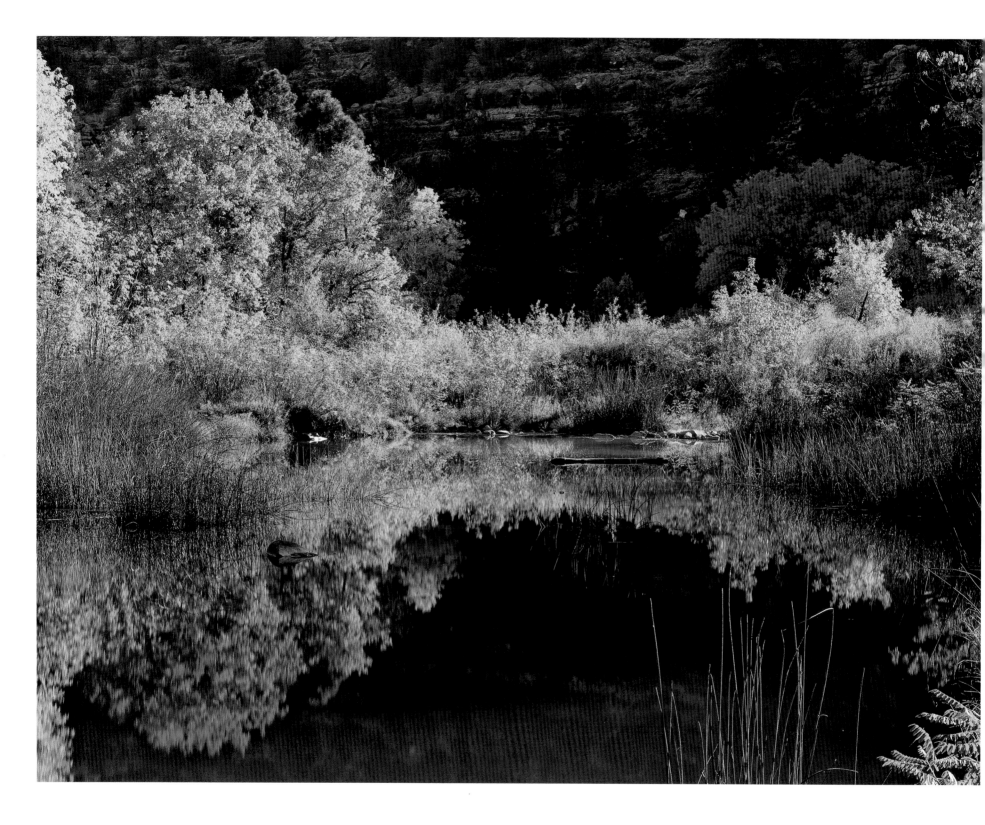

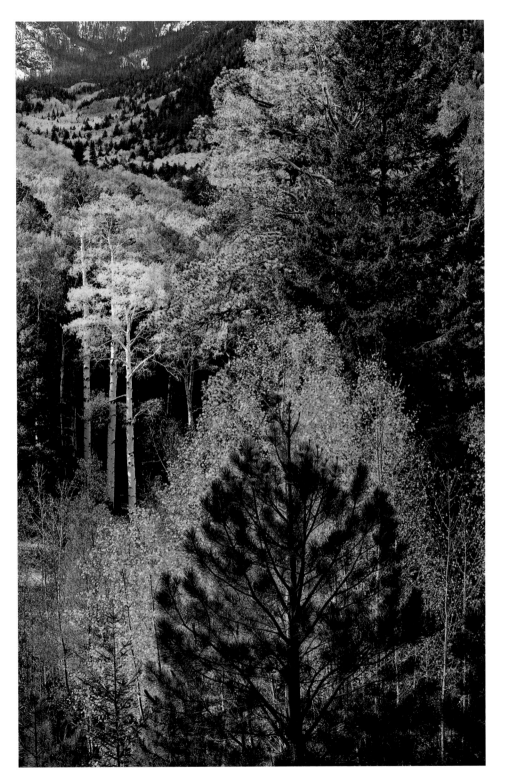

BRUSHY BANKS
[opposite page] Thickets
of russet and amber
rustle with wildlife
seeking food and shelter
along Chevelon Creek.
| *Nick Berezenko*

**ASPENS AND
EVERGREENS**
[left] The leaves
of deciduous and
coniferous trees create
a mosaic of color on the
eastern slopes of the
San Francisco Peaks.
| *Paul Gill*

SOFT DAWN
[above] Four Peaks loom over the fog lifting from Theodore Roosevelt Lake following rain at sunrise in the Sierra Ancha Wilderness. | *George Stocking*

MIX IT UP
[opposite page] Maples, oaks, piñons, and junipers mingle on a warm, south-facing slope on the North Rim of Grand Canyon. | *Chuck Lawsen*

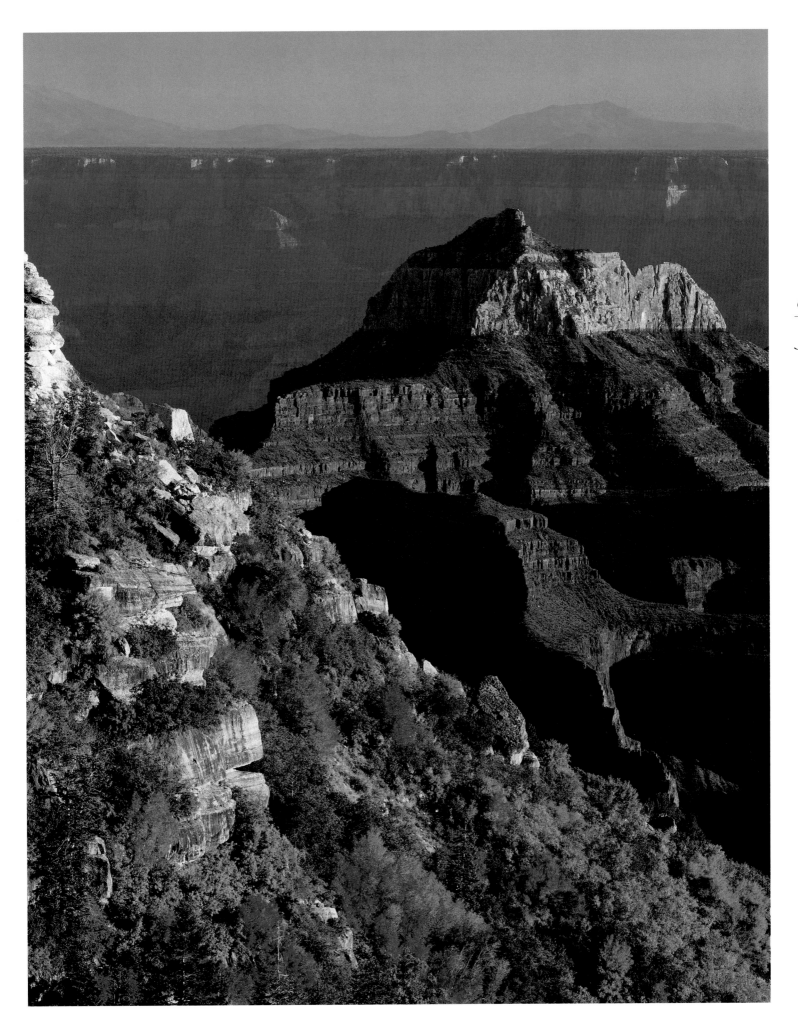

FALL FLOURISH
[right] Rabbitbrush and aspens ornament the stark contours of the San Francisco Peaks Volcanic Field, Sunset Crater Volcano National Monument. | *Tom Danielsen*

HUDDLED MASSES
[opposite page] Eroded volcanic boulders cluster on an exposed ridge in the Mount Baldy Wilderness. | *Robert G. McDonald*

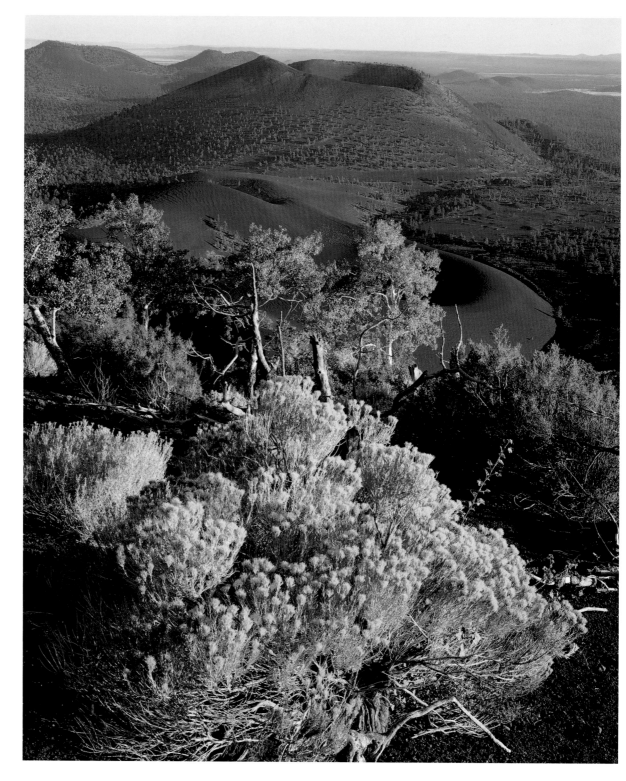

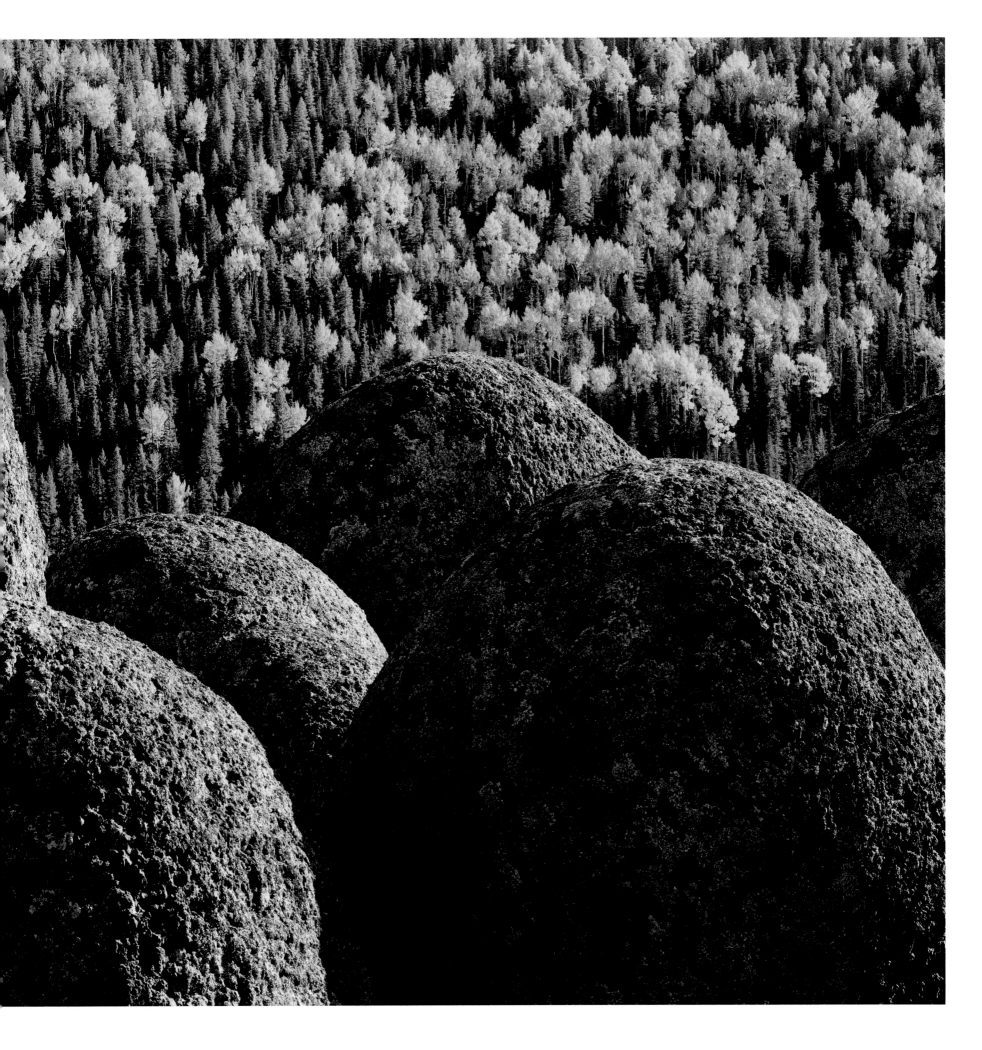

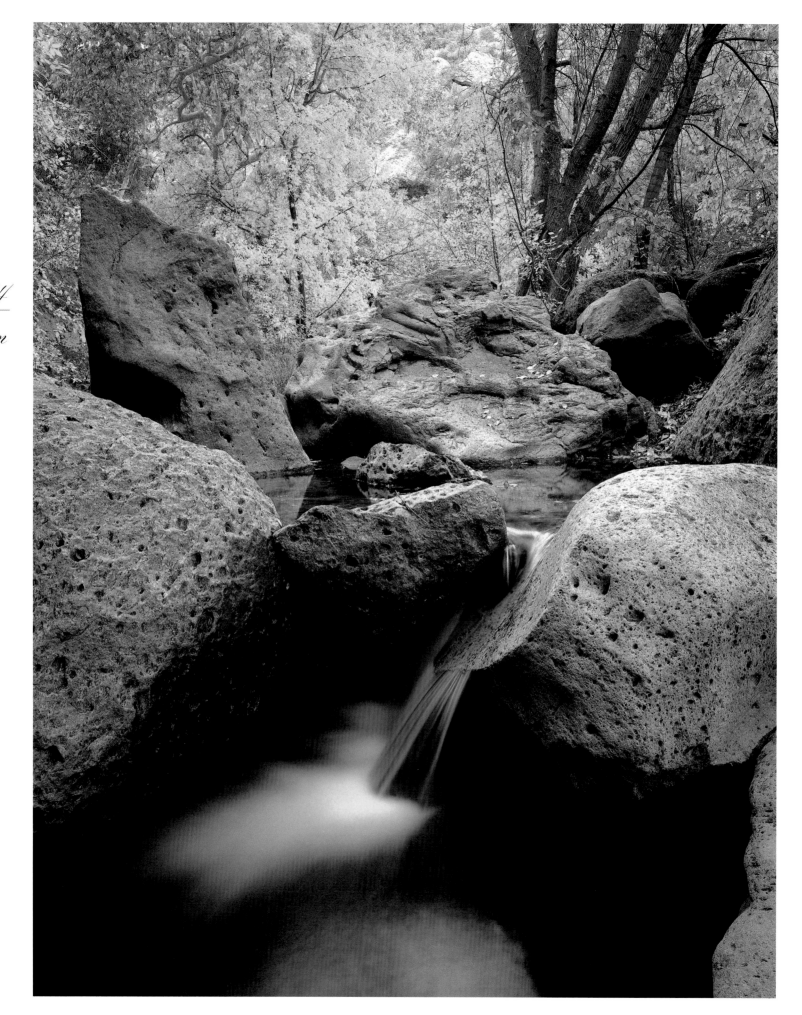

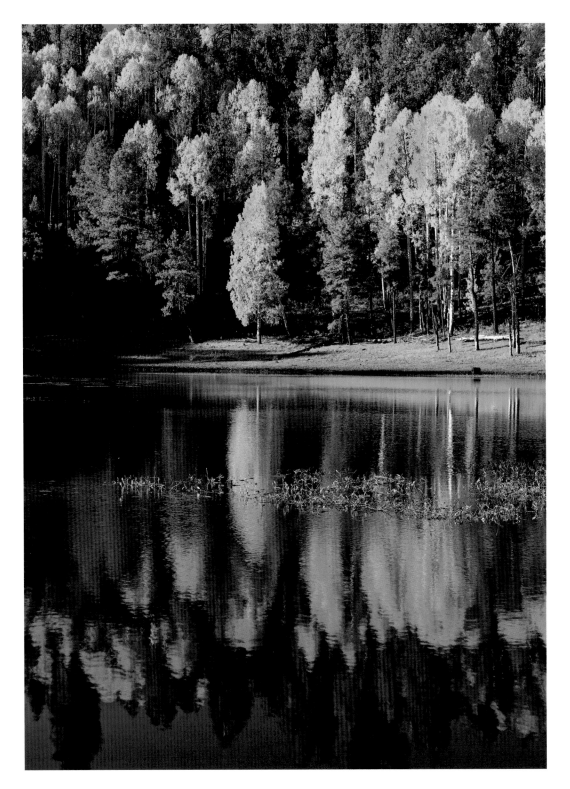

ROUGH AND
SMOOTH
[opposite page] Box elder
and Arizona sycamore
surround a jumble of
streamworn boulders in
the Aravaipa Canyon
Wilderness. | *Jack
Dykinga*

LIGHT AND DARK
[left] Potato Lake echoes
the colors and patterns
of the autumn forest
on the Mogollon Rim,
Coconino National
Forest. | *Nick Berezenko*

Winter *Dormancy & Reflection*

Here we are, in the homeland. It is winter, and it will be spring again. We have known other winters, and survived them…. I can report now that grass grows, flowers bloom, birds sing. I can report that the sun rises and sets, the moon keeps its own schedule, the stars follow patterns they have followed since man first saw them in the night sky. I know these truths. Lesser truths will take more learning, but I can live with what I now know. — *Hal Borland,* Book of Days, 1976

OUT IN THE COLD
Snow on a ponderosa sapling makes starburst patterns against old-growth giants in Fay Canyon near Flagstaff. | *Tom Bean*

Tom Bean

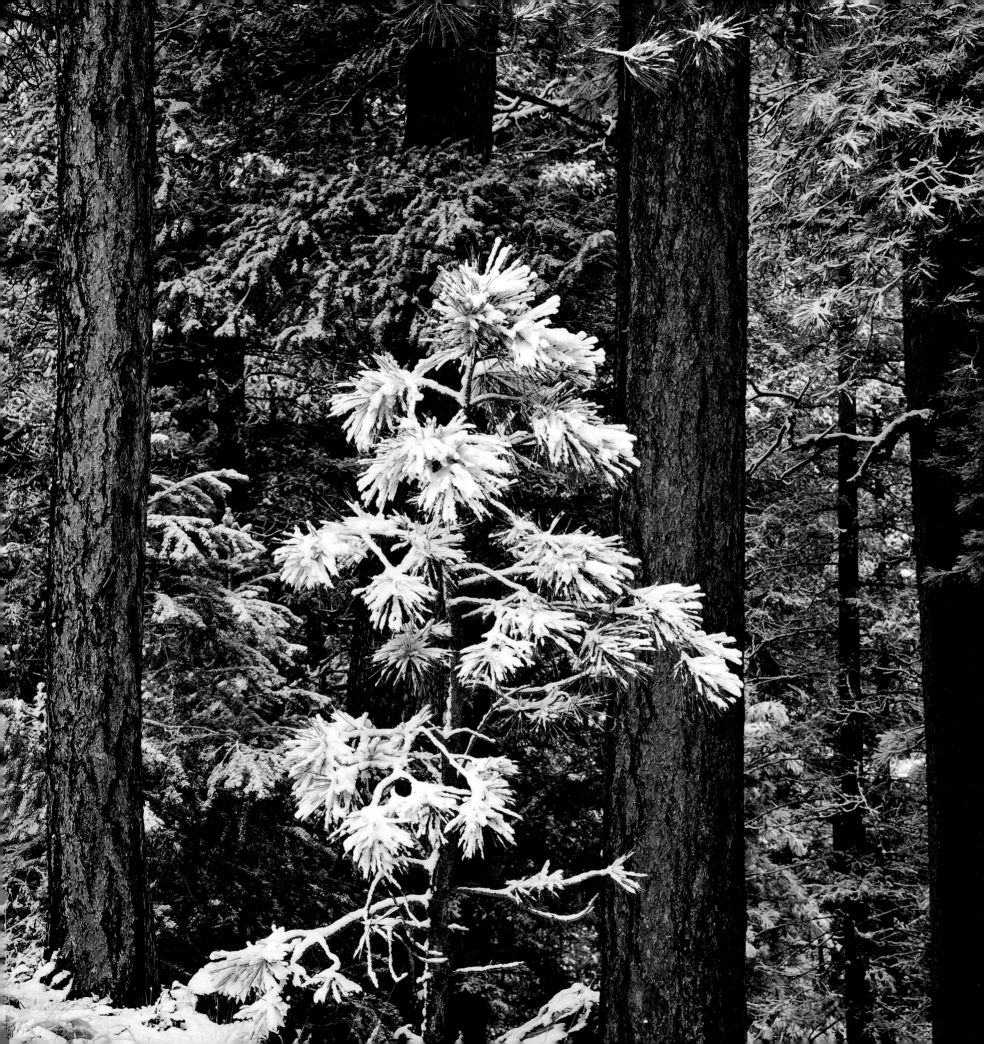

Elder Brother's Advice

Elder Brother created people out of clay and gave to them the "crimson evening," which is regarded by the Papago [Tohono O'odham] as one of the most beautiful sights in that region. The sunset light is reflected on the mountains with a peculiar radiance. Elder Brother told the Papago to remain where they were in that land which is the center of all things. And there the desert people have always lived. They are living there this very day. And from his home among the towering cliffs and crags of Baboquivari, the lonely, cloud-veiled peak, their Elder Brother, I'itoi, spirit of goodness, who must dwell in the center of all things, watches over them.

— Bernard L. Fontana,
Of Earth and Little Rain, 1989

Winter in Arizona is a time for reflection. For most living things, long nights and brief days mean turning inward. Paloverdes, cottonwoods, and ash trees drop their leaves; lizards and snakes grow torpid. In the northern uplands, the cold and the chance of snow send soft-leaved plants, prairie dogs, and chipmunks into dormancy, just barely alive below ground. Bright colors fade, earth colors deepen.

Winter exposes the land to a slanting, watery sunlight. Cooler temperatures and fewer hours of sunshine make it natural for things to calm down. The forests are quiet, the deserts subdued.

Even the storms are slower-paced, farther apart, and less intense than late summer's brief daily outbursts. Occasionally, a bank of low, cottony clouds moves in from the Pacific, gently sifting down rain and snow. Though only about half of Arizona's moisture falls in winter, it accounts for nearly all its flowing waters. In good years drought is relieved, springs and rivers are restored.

The rinsed winter air is dry, cool, and undistorted. Winter nights close in early and the circling stars are very bright. There are often so many stars visible that they blur the constellations. It may take a few moments to find, say, Orion and his dogs in pursuit of the Pleiades. Stargazers can watch for hours and still have time for some sleep.

Winter has always been the time to tell stories — especially myths of creation and what they say about life. It is a time of ceremonies based on those stories in all of Arizona's regions and cultures, including the recent ones. Winter stories, feasts, and celebrations renew body and soul in advance of the coming year.

Low Desert Bliss
Sonoran: Early Revival

Even during winter's briefest days, life in the Sonoran Desert doesn't entirely let up. A few plants bloom in response to the cool season rains — pink puffs on fairyduster, red flowers on chuparosas, and yellow blossoms on creosote.

Temperatures are mild, especially in the far southwest corner of the state. With the days barely lengthening after midwinter, life in the Sonoran begins afresh. January is mating

season for many creatures, from mule deer to packrats. Bighorn sheep scramble up the rocky slopes of mountain wildlife refuges like the Kofa, snorting and jousting with rivals. Snakes and lizards begin to stir.

In the uplands, amorous curve-billed thrashers sing from saguaros; mockingbirds call out in courtship. Cactus wrens build nests in chollas; male phainopeplas dance in the air. Ironwood, paloverde, and mesquite trees shelter fragile seedlings from sporadic frosts.

Among the Sonoran Sky Islands to the east is Baboquivari, visible from everywhere in Tohono O'odham country. The spirit of their Elder Brother I'itoi — who taught the people right from wrong — lives here. The four long nights of the winter solstice are the traditional time for O'odham stories of the Creation, of I'itoi's death and rebirth.

Mohave: Rains and Refuge

The Colorado River below Black Canyon is a haven for shorebirds. It is among the few naturally noisy places in Arizona during the winter, as thousands of migrating snow and Canada geese splash here and honk. A kaleidoscope of ducks — mallards, teal, wigeons, goldeneyes, gadwalls, and buffleheads — paddle, dabble, and dive in the river. Spotted sandpipers and American pipits hustle on beaches. Stilts and avocets wade in the shallows, while grebes and cormorants dive for their prey. Marsh wrens and blackbirds call from the cattails and bulrushes.

Away from the river, the Mohave Desert often freezes on winter nights. But the ever-present winds are calmest during this season, and the evening air is humid. Winter is the "wet" season here, when most of the year's few inches of rain come from the Pacific.

[top] Western diamondback. | *George H.H. Huey*
[above] Granite spiny lizard. | *Paul and Joyce Berquist*

Keepers of the River

For the Mojave, as for other indigenous people, story, song, and landscape are inseparable. Multiple layers of meaning accompany the legendary journey of the Mojave through the natural landscape, and the difference between the mythical and practical, the natural and supernatural vanishes like smoke.
— Philip M. Klasky,
The Storyscape Project

Mojave people call themselves Aha Macav, Keepers of the River, and believe the Colorado was given them by Mastamho, the Creator's little brother. But they feel a responsibility for the land as well, and for the mountains that their stories say are made from river mud. A cycle of over five hundred Mojave songs tells of their origins, mythological and heroic journeys, and sacred sites. Embedded in these songs are instructions about survival, healing, virtue, and death.

At Home in the Desert

I cannot think that we are useless or God would not have created us.... The sun, the darkness, the winds are all listening to what we have to say.

— Geronimo

The flat valleys and Sky Islands of the Chihuahuan Desert were once home to the Chiricahua Apaches, who hunted and gathered rather than settle and farm. Odd that a people so footloose should have such a strong sense of place, but they did, revering the land that sustained them.

Chihuahuan: Winter Haven

The Chihuahuan Desert is cold in winter, with a hundred freezing nights in an average year. It is dry during this season too, as the desert lies between dark, ragged mountains — Dos Cabezas, Rincons, Huachucas, and Chiricahuas — that intercept moisture-bearing clouds. Lonesome country, it is flat yet varied with drying grasses native to the Great Plains alternating with Chihuahuan desert scrub, its shrubs mostly leafless in winter. Soaptree yuccas dot the vastness, under a horizon crenellated with mountain crests like Gothic battlements. Lark buntings spend autumn through spring there; pyrrhuloxias stay the whole year.

At Willcox Playa and Whitewater Draw, returning sandhill cranes materialize at dusk in a deep turquoise sky already dotted with stars. They murmur on mudflats till dawn, then fly off to forage in grainfields long since harvested. As they disappear into the sky, hundreds upon hundreds of their six-foot wingspans resolve into wavering 'v's called skeins. A few avocets take their place on the flats, prodding the mud with their bills.

Sandhill cranes set to land. | *Bruce D. Taubert*

The Chihuahuan mountains are quiet in winter, with snow possible from November to March. Coatis form troops in the canyons where mountain lions stalk white-tailed deer. Woodpeckers, nuthatches, and brown creepers probe at the bark of pines while towhees scuff in the dirt under brush. In nature preserves in the foothills, cardinals, sapsuckers, and wrens flutter in woodlands along the streams. Amid leafless branches along the San Pedro and Santa Cruz rivers, warblers and flycatchers are easier to see.

Central Highlands
Mix of Mild and Harsh

Winter magnifies the differences between the basins and mountains of the Central Arizona Highlands. It is a pleasant time of year in the Verde, Lonesome, and Chino valleys, the Tonto Basin and Big Prairie. They are tawny again, with long, branching stalks arching delicately over clumps of drooping bunchgrass. Kestrels, most delicate of falcons, hover above the ground to pounce on voles scurrying down tunnel-like runways. Bald eagles wintering along the Verde River feast on fish; northern harriers are seen coursing over open country in the Verde and Chino valleys. The days are mostly sunny but frosts and hard freezes are frequent.

[top] Bald eagle. | *Bruce D. Taubert*
[above] Mule deer. | *Randy Prentice*

Crissal thrashers slip through the dense chaparral blanketing the hills and canyons surrounding the valleys. Because the chaparral is mostly evergreen, it doesn't look much different from early summer or fall — still grayish, still waist-high, still scratchy. Small groups of collared peccaries, loafers at noon in summer, are active all day in the winter, chomping on prickly pear pads and digging up roots and worms. Occasional snowfalls dust these foothills, highlighting their crests. Brushy slopes shine with sunlight slanting through chaparral outlined with frost. Below the Mogollon Rim, Sedona's sandstone shapes look their deepest red in contrast to the snow.

Ranges are loftier in the eastern highlands, the foothills more rugged. Creeks purling down from the mountains dissect the slopes. Chaparral gives way to woodland. Flocks of cedar waxwings tug at the chokecherries while mule deer browse ceanothus twigs. In winter, when leaves are gone from streamside shrubs, the details of the landscape are exposed: small

Lessons of the Land

After she came to the Earth, White Changing Woman gave birth to two boys, Child of Water and Child of Sun. They had many adventures still told by the Apaches, and made the Earth safe for the People.
> — Chesley Goseyun Wilson,
> Western Apache

Ethnologist Keith Basso has worked with Apaches — the Ndee — for decades. In *Wisdom Sits in Places* (University of New Mexico Press, 1996), Basso explains what the Apaches have said and shown to him — that there are stories about ordinary people as well as the ancient ones associated with the place-names of their homeland. All are moral tales, infused with lessons about life. As 77-year-old Annie Peaches put it: "The land makes people live right."

River Stories

We have an unknown distance yet to run, an unknown river to explore. What falls there are, we know not; what rocks beset the channel, we know not; what walls rise over the river, we know not. Ah, well! We may conjecture many things. The men talk as cheerfully as ever; jests are bandied about freely this morning; but to me the cheer is somber and the jests are ghastly.

— Major John Wesley Powell, 1869

The Colorado River through Grand Canyon is one place in modern America where the storytelling tradition is alive and well. Any boatman worth his or her salt can conjure a tale and recite the tales of others. The stories are about those who have come down the river before — of courage and fellowship, of danger and fun.

grassy openings around springs, the rocky walls of canyons choked by stream-flung boulders, petroglyphs along brooks.

In the watery air of midwinter, blue-gray mountains dominate the horizons and cast long shadows on the opposite slopes. Cold air drains down their canyons from the Mogollon Rim. Storm fronts bring snow that can result in a springtime runoff, which overwhelms streams. Many birds leave and the forests grow quiet, especially on overcast days. Activity slows and travel is challenging; the highlands become more remote.

Mogollon Rim. | Jerry Jacka

Plateau Country
Extremes and Surprises

Winter unifies the plateau and canyon country. Unlike the small, choosy rainstorms of summer, winter storm fronts seize the whole region. When it is cold and wet in one place, it is cold and wet just about everywhere. By the same token, there can be weeks of calm days so dry that features on the horizon are clear from a hundred miles away.

The plateau's winter palette is somber, like the deep vegetal colors of a Wide Ruins Navajo rug: onion-yellow earth, rust red rock, sage-green brush, graybark sky. This is a time when the sweep of the landscape and the infinite sky speak of simplicity, survival, and grace.

On the narrow Hopi mesas, smoke curls from ancient stone roofs. Before the solstice there is intentional foolishness; afterward, there is care. *Nuva'tuqui ovi*, the distant San Francisco Peaks, shine with snow on the southwest horizon.

Surrounding the mesa villages, waves of winter storm clouds roll across *Dinetah*, the Navajo Nation, a landscape animated by story and light. Stories of Monsterslayer are told

there, and of the monsters too. Huge ravens with ruffled necks caw and swoop with the wind above streaked sandstone cliffs. Winter ceremonies begin when the Pleiades appear in the eastern sky.

Improbable shapes loom out of the fog and snow — eroded volcanic necks and sedimentary mesas stair-stepping down to shallow draws that snake across the land. The landscape undulates through fields of cinder cones and lava flows, where snow makes patterns of lines on black hillsides like Puebloan pottery designs. Muddy washes converge on playas outlined by dark twiggy trees, red-purple willow shoots, and greasewood. Wide valleys with clumps of cottonwoods become ephemeral marshes. To the north, the Echo and Vermilion Cliffs glow like brass in the low winter light of a still evening. Flocks of western bluebirds flit from piñon to juniper, staying in touch using little chirps. The precisely spaced suite of plants is quintessentially Colorado Plateau: piñons, junipers, mountain mahoganies, snakeweed, yucca, Mormon tea.

Near the southwest edge of the Colorado Plateau loom the San Francisco Peaks, sacred

Sunset Crater Volcano National Monument. | *Jerry Sieve*

In the evening the Mexicans obtained permission to build fires, say mass, and fire four rounds of cartridges in commemoration of "buenas noches." They commenced soon after dark by setting fire to the thick trees round camp so that at one time there were near a dozen fires going, illuminating everything around.... During the conflagration of pines one read mass and at certain portions of the service guns were discharged by the others.
— John Sherburne, Christmas, 1853

After Arizona north of the Gila River was transferred to the United States with the 1848 Treaty of Guadalupe Hidalgo, several expeditions surveyed the 35th parallel across northern Arizona. The Beale Expedition of 1857 tested the feasibility of using camels to carry supplies along the route. John Sherburne joined the Whipple Expedition to survey a potential route for a railroad along the 35th when he was just twenty-one years old. High-spirited and full of enthusiasm, he had the time of his life on the trail.

Havasu (Cataract) Canyon

Whithersoever I have gone I have seen no situation more strong and secure by nature. Close by runs the Rio Jabesúa, which arises in the labyrinth of caxones there are in every direction; the course it here takes is to the westnorthwest and north, and at a little distance it falls into the Rio Colorado.
— Father Francisco Hermenegildo Tomás Garcés

The Havasupai people left their deep canyon in winter to hunt on the plateau. In their Creation story, it was Red Butte — Mat Taav Tiivjundjva — at the head of Cataract Canyon where they were created. It continues to renew them each year.

to all of the native people of the region. Many make pilgrimages to the mountains to visit shrines and collect plants.

The peaks are the most extreme expression of winter in Arizona. A highly adapted community of specialized plants and insects has developed in response to the challenging environment on their north-facing slopes. Tundra caps Humphreys Peak at 12,643 feet above sea level, more than a mile above its surroundings. Cold, snow, and high winds batter the tundra all winter, raising a white banner of snow visible for thirty miles. Yet about ninety different plants survive this deep freeze to bloom again late in the summer. A small bit of treeless meadow persists on Mount Baldy in the White Mountains, as well. In both places, collars of krummholz — the twisted trunks and branches of wind-wrestled bristlecone pine, fir, and Engelmann spruce — fringe the lower edge of the tundra.

Spruce and fir gain their full height lower down, as well as on the highest of the Sky Islands to the south. They form dark, crowded forests that allow little light to reach the ground. Things open up more below, where patches of ghostly white aspen trunks gleam among white and corkbark firs, limber pines, and Douglas firs. These trees blend down slope with multitudes of ponderosas and spindly Gambel oaks.

Ponderosa forest bristles everywhere across Arizona at elevations between about six thousand and eight thousand feet. In winter, it is the haunt of Steller's jays, their raspy cries rousing each other to mischief as their blue wings flash among the trees. Bobcat tracks wind

[top] Coyote in snowstorm. | *Tom Bean*
[above] Cottontail rabbit. | *Tom Bean*

through snowy openings; the paw prints of coyotes and gray fox meander in snowbound draws. Bald eagles perch on snags above the half-frozen lakes on upland lava flows, while wintering ducks — mallards, pintails, and mergansers — share the lakeshore with Canada geese.

No matter where we are in Arizona, the shorter, cooler days of winter remind us that this state does indeed experience every season of the year. Getting to know these seasons in all of their many glories helps us to be truly part of our own place and time.

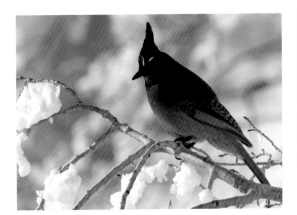

Steller's jay. | *Bruce D. Taubert*

A Mile of Diversity

The mile-deep Grand Canyon gives us all the regions of Arizona at once. This is especially obvious in winter, when there are desert wildflowers in the Inner Gorge and snow on the rim. This magnificent place stuns all who see it the first time; most need more than a few moments to take it in. As Clarence Dutton wrote after the 1875 Powell Survey, the Grand Canyon is truly "a great innovation in our modern ideas of scenery".

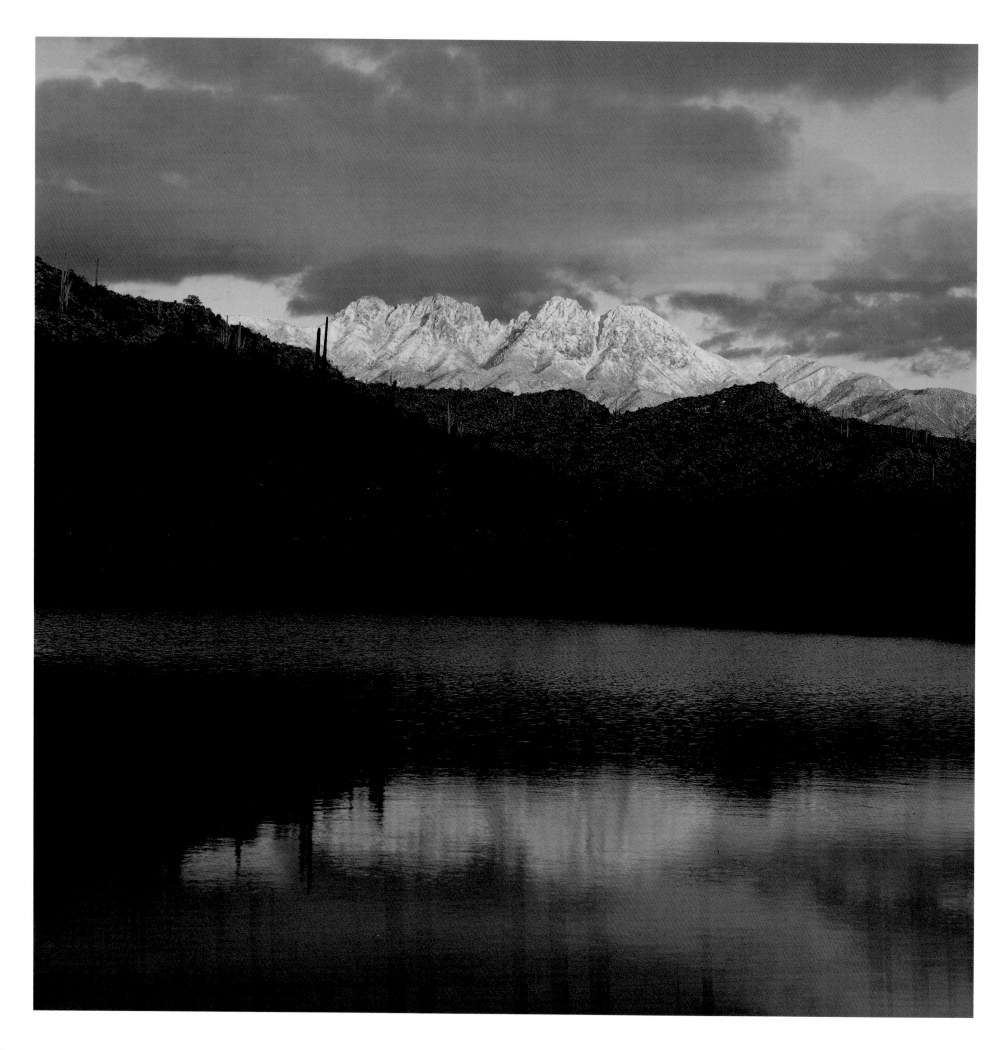

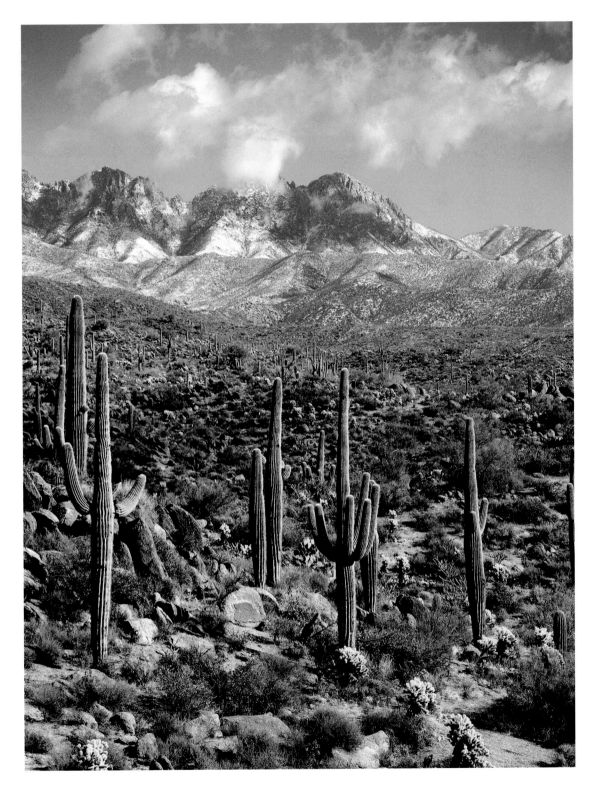

TWILIGHT
GLEAMING
[opposite page] A rosy
sunset glow on the snow-
clad crags of Four Peaks
reflects in a stock pond
northeast of Phoenix.
| *Jerry Jacka*

TO THE PEAKS
[left] Saguaro cactuses
march up the bajadas
toward Arizona's iconic
Four Peaks at the
southern end of the
Mazatzal Mountains.
| *Paul Gill*

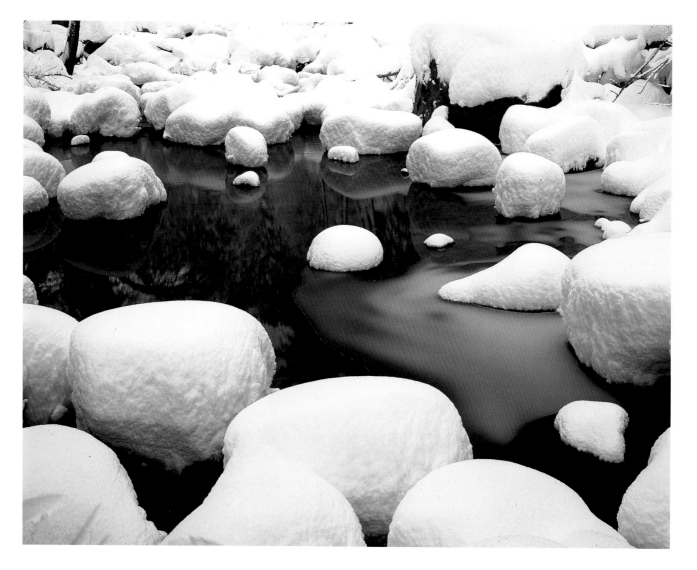

SNOW MUFFINS
[above] Snow-covered
stones in Oak Creek
look like baking powder
biscuits to a fanciful
photographer, Coconino
National Forest. | *Robert
G. McDonald*

DESERT VARNISH
[opposite page] Streaks
of meltwater deposit
mineral stains on a sheer
sandstone cliff in the West
Fork of Oak Creek.
| *Robert G. McDonald*

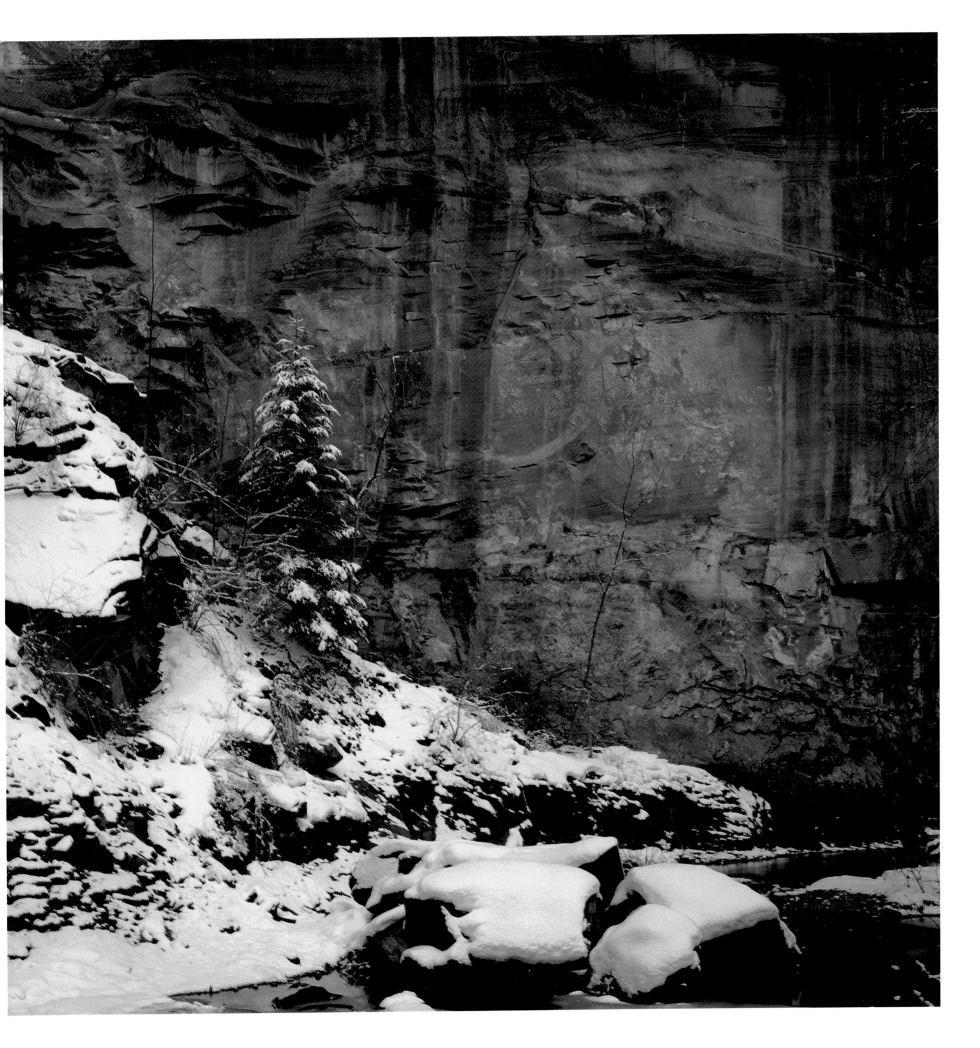

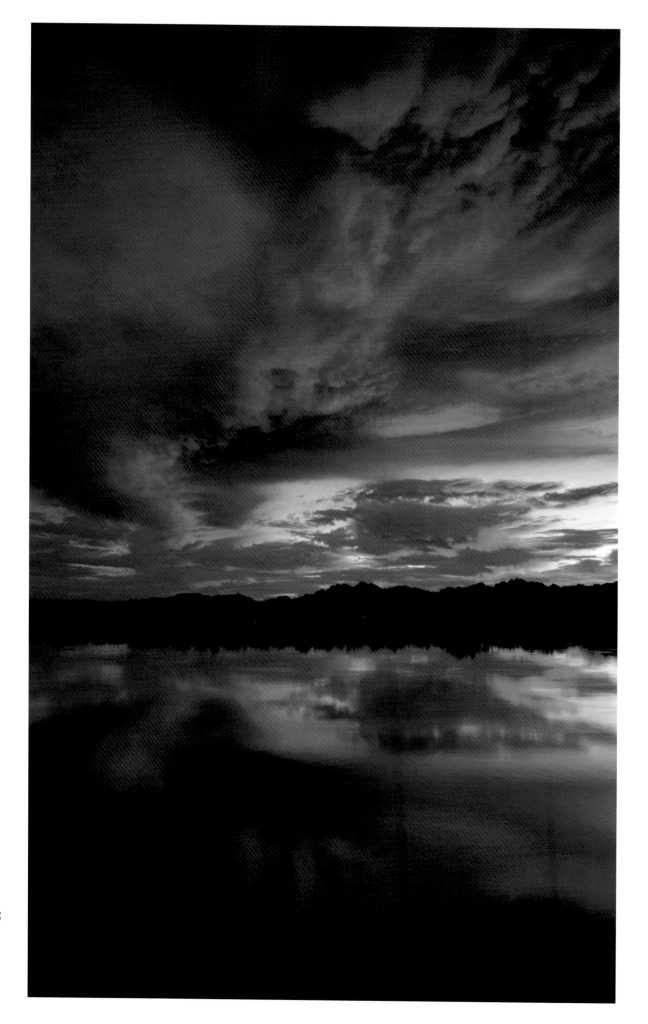

CRIMSON CLOUDS
The Colorado River
reflects a vermilion-
saturated sky at daybreak,
Cibola National Wildlife
Refuge. | *George Stocking*

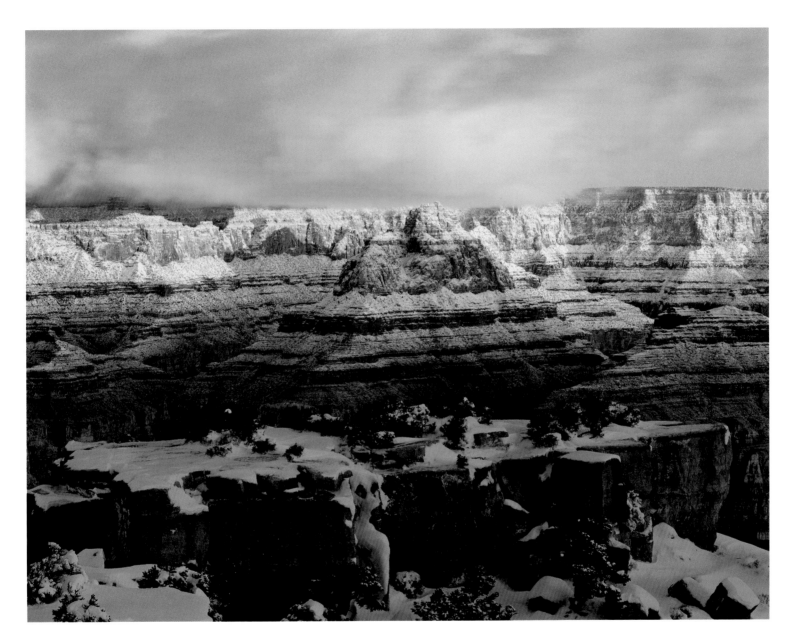

SKY AND STONE
A winter cloud bank
brushes the top of the
Kaibab Plateau just
beyond Vishnu Temple
in the Grand Canyon.
| *Randy Prentice*

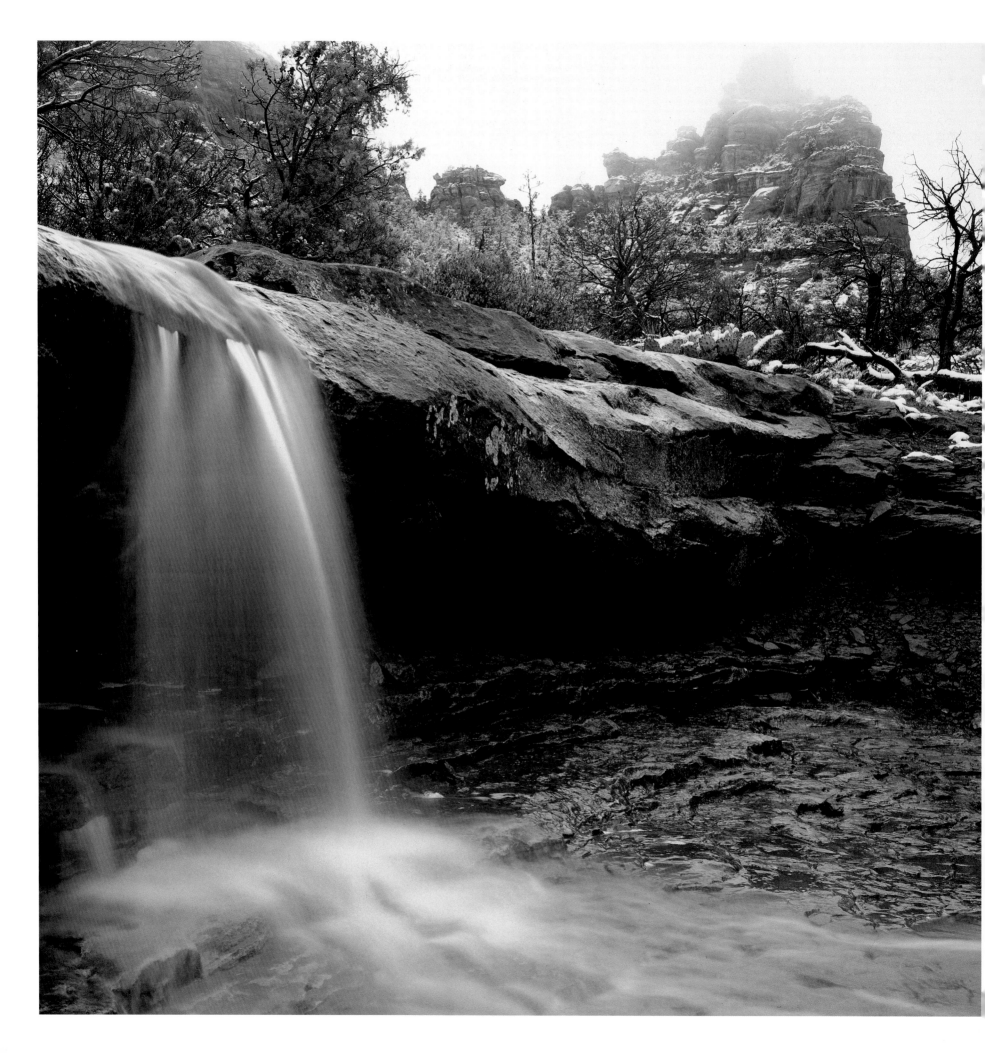

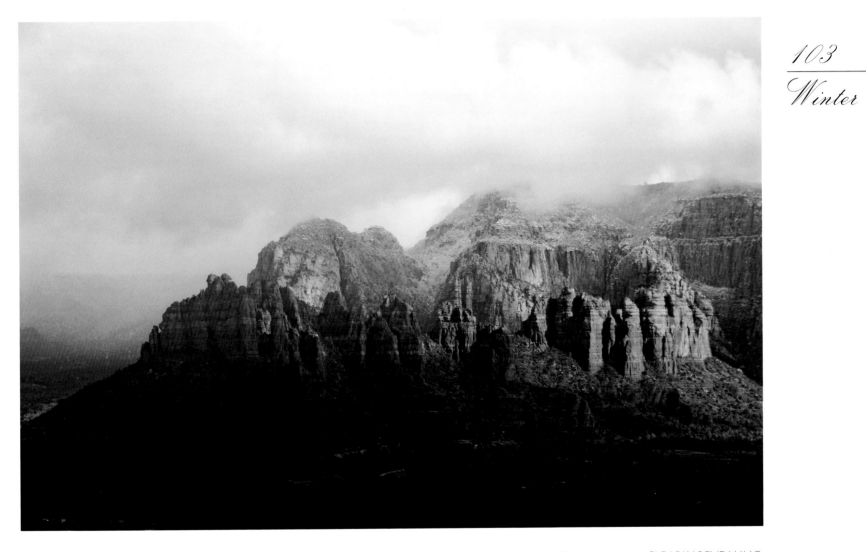

SNOWMELT
WATERFALL
[opposite page] Snow
falling at the point of
freezing quickly melts on
the sandstone of Munds
Mountain, Coconino
National Forest. | *Robert
G. McDonald*

CLEARLY REVEALING
[above] Sunlight again
illuminates Munds
Mountain when a winter
storm begins to clear
near Sedona, Coconino
National Forest. | *Chuck
Lawsen*

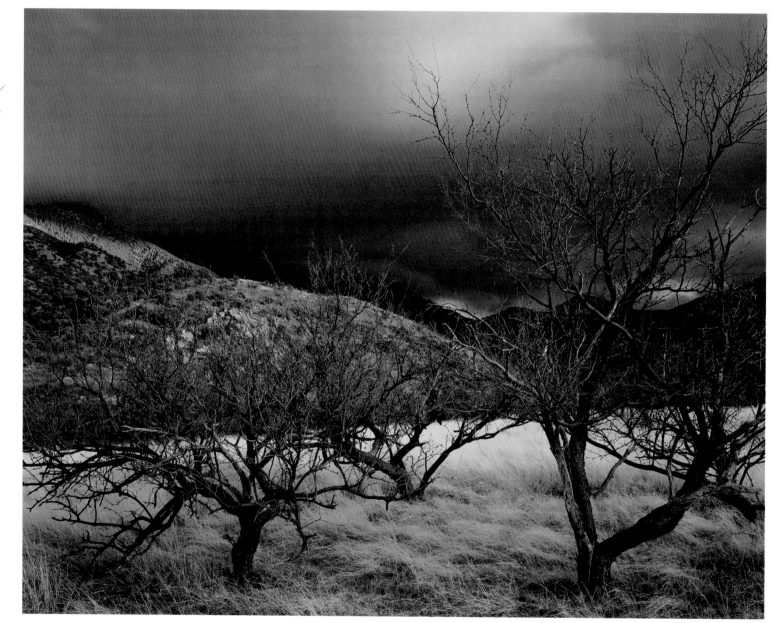

LAST LIGHT
At dusk, a winter storm
approaches over the
mesquite-covered
grasslands near Madera
Canyon, Santa Rita
Mountains. | *Randy
Prentice*

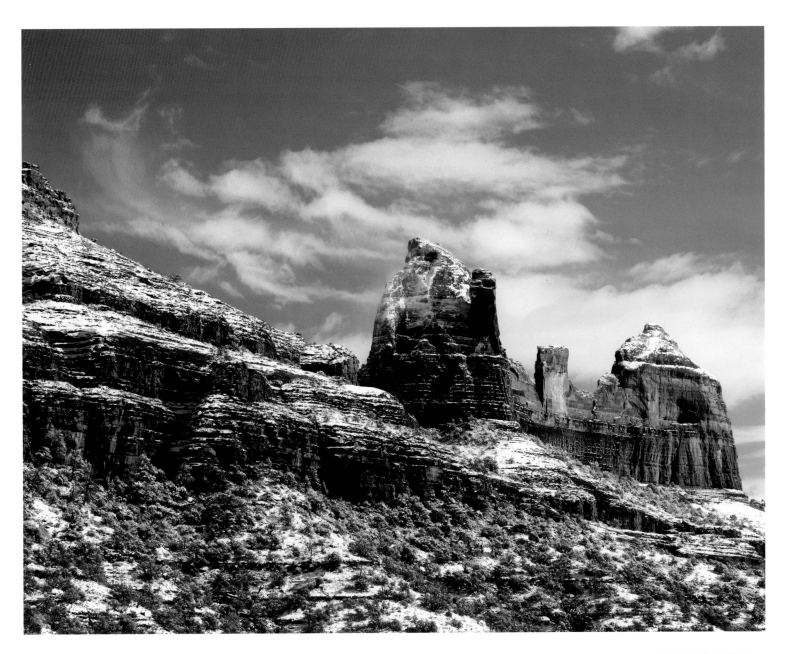

AFTER THE STORM
A brilliant blue sky
looks all-too-innocent
after showering fresh
snow on Mitten Ridge
near Sedona. | *Morey K.
Milbradt*

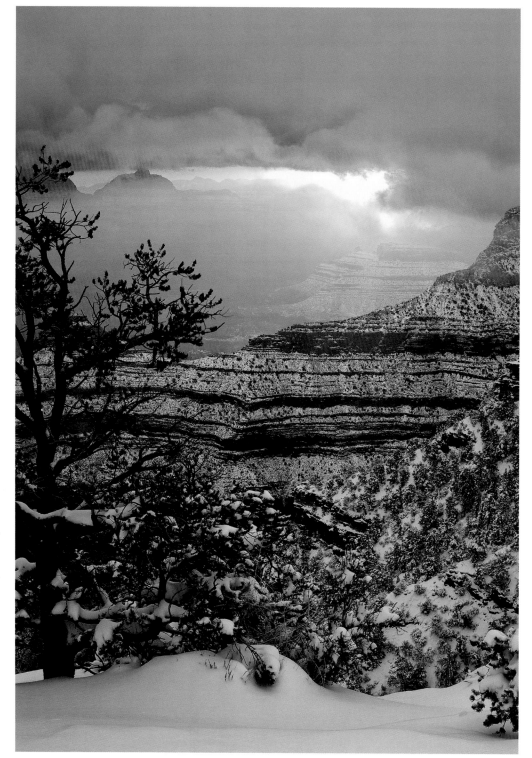

BREAK OF DAWN
[right] East of Yaki Point, the rising sun floods a cold and snowy Grand Canyon with light after a stormy night. | *Morey K. Milbradt*

DIFFERENT WORLDS
[opposite page] The forested, snowclad San Francisco Peaks loom beyond the arid sand dunes of Ward Terrace, Navajo Nation. | *Tom Bean*

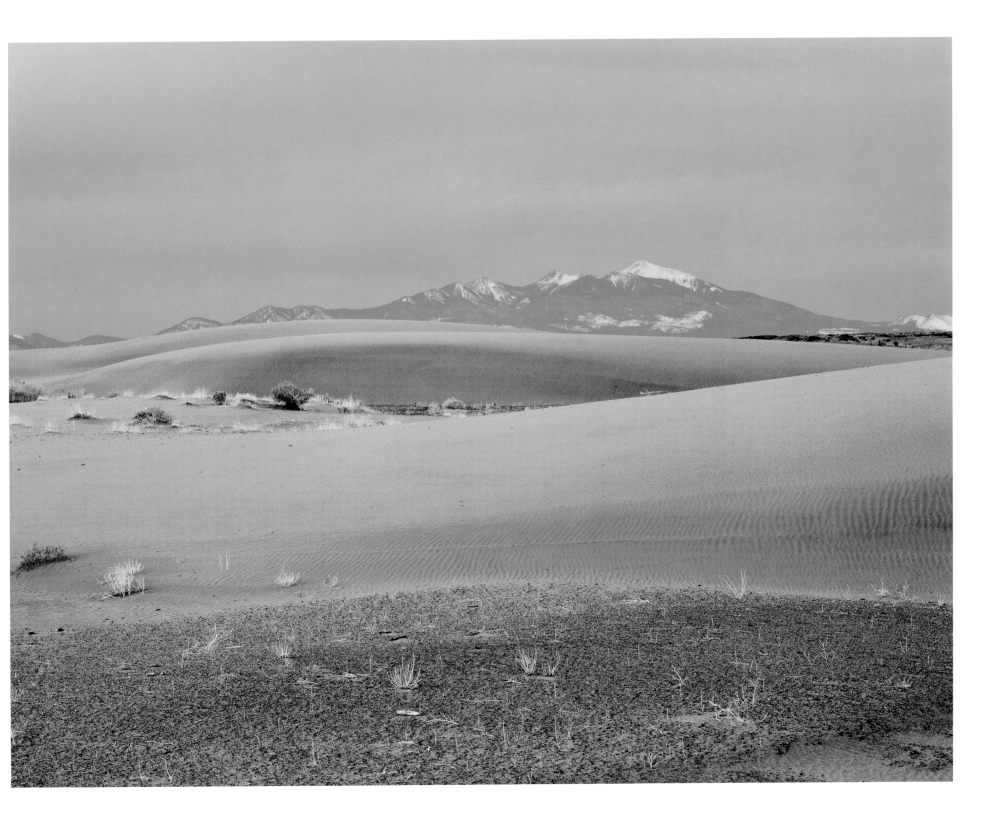

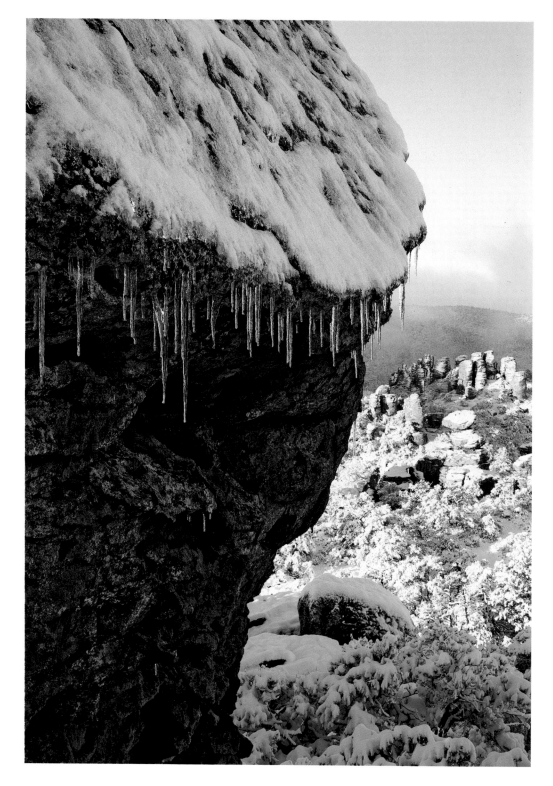

FROZEN FLOW
[right] Melting snow
freezes into icycles at
Massai Point, Chiricahua
National Monument.
| *Randy Prentice*

RARE EVENT
[opposite page] A storm
on Christmas Day leaves
snow on the saguaros
of Finger Rock Canyon
in the Santa Catalina
Mountains. | *Jack Dykinga*

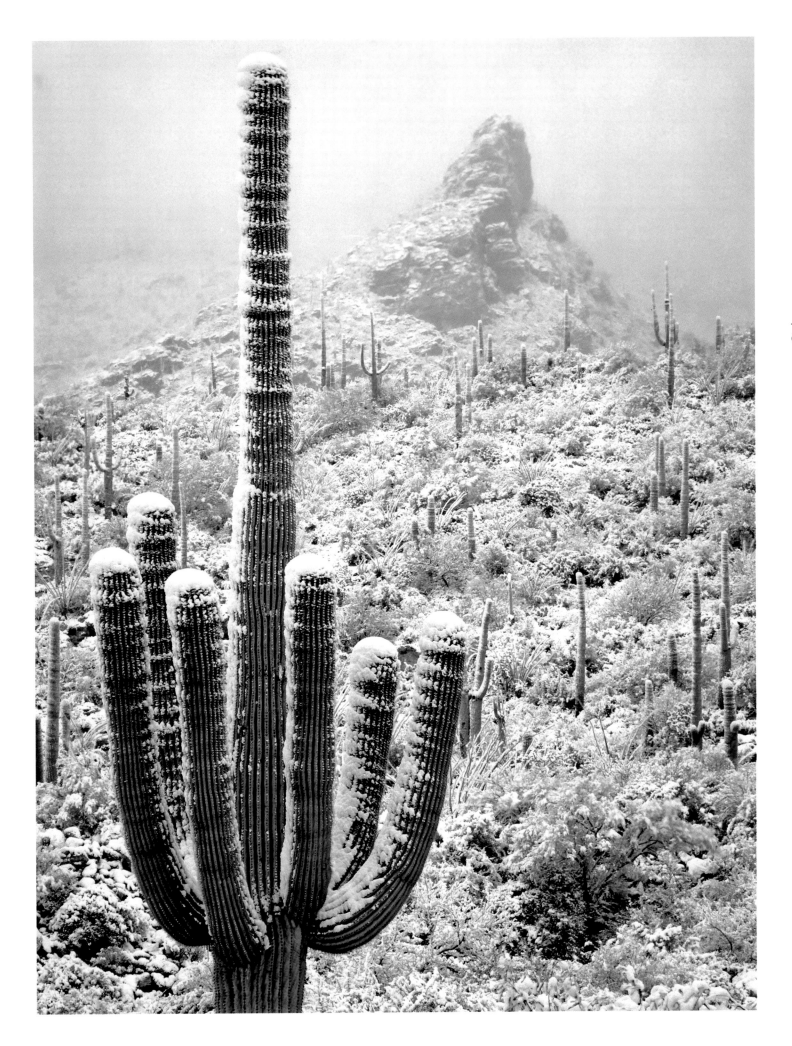

Acknowledgments

They say it takes a village to raise a child. This project reminded me that it takes a community to produce a book. Many people generously took the time to explain aspects of Arizona's natural and cultural wonders to me while also engaged in their own field work, research, teaching, and community programs.

I thank Dr. Larry Stevens, honorary curator of ecology and conservation at the Museum of Northern Arizona, for sharing his encyclopedic knowledge of living things and his passion for conservation. Geologist and globetrotting study leader Wayne Ranney brought me up to date on geologic processes while writing his own book on the ancient landscapes of the Colorado Plateau. Botanist Jessa Fisher, assistant herbarium curator for the Arizona Ethnobotanical Research Association, reviewed the descriptions of plant communities and the rapidly changing nomenclature of plants. Field ornithologist John Coons shared his fascination with the beauty and behavior of birds. Meteorologist Lee Born, Flagstaff's dependable television "weatherman" for over seven years, checked the explanations of Arizona's climate. Bryan Bates, Coconino Community College math and science instructor, offered his remarkable research into archaeoastronomy.

I am grateful to them all for reviewing the manuscript. Any omissions or mistakes that remain are my own.

Arizona's photography community is legendary. I have joined many of its gifted photographers on adventures and appreciate the lengths to which they go to celebrate the beauty of our state. My photographer husband Tom Bean's delight in the natural world has been particularly inspiring to me.

I owe a special debt of gratitude to Eric, Jane, and Lance Polingyouma, who over the past twenty years have quietly opened my eyes to the ancient ways of life that persist in all parts of Arizona, especially the Hopi mesas.

I would also like to thank former *Arizona Highways* book editor Bob Albano for his insights and encouragement during the writing of this book, senior editor Randy Summerlin for so capably seeing the project through to completion, Beth Deveny for her careful editing, and Mary Velgos for her lovely design.

—*Susan Lamb*

112